TEWKESBURY

THROUGH THE YEAR

Stephen Lambe

Acknowledgements

Anthea Jones' superb history, *Tewkesbury* (Phillimore, 1987) has been a huge help in compiling the little historical snippets that pepper this book, alongside websites for Tewkesbury Abbey, Tewkesbury Baptist Church, Tewkesbury Mop Society, Tewkesbury. net, Tewkesbury Town Council and and Out of the Hat. Thanks also to Cliff Burd and Charles Hilton for their past books on the town.

I would also like to thank to Ian Nicholson at Alison's Bookshop, Julie Wood, Katie Power, Dan Judges and my wife Gill.

First published 2011

Amberley Publishing
The Hill, Stroud
Gloucestershire, GL5 4EP

www.amberley-books.com

Copyright © Stephen Lambe, 2011

The right of Stephen Lambe to be identified as the Author of this work has been asserted in accordance with the Copyrights, Designs and Patents Act 1988.

ISBN 978 1 4456 0668 2

British Library Cataloguing in Publication Data. A catalogue record for this book is available from the British Library.

Typesetting by Amberley Publishing.
Printed in Great Britain.

Introduction

The market town of Tewkesbury in North Gloucestershire is unique. Its character and appearance has been informed by over 1,000 years of history plus an accident of geography which placed it at the meeting point of the rivers Severn and Avon.

I have lived in Tewkesbury since 2005 and this book uses new or recently taken photographs to trace the life of Tewkesbury, concentrating largely on the town centre, through the course of a typical, rather than a specific year. Of course, a little poetic licence has been used, and for the first time I have published a few of my photographs from the floods of July 2007 alongside some pictures of the post flood celebrations one year later. These are hardly typical, although given its unique position geographically, dealing with flooding has been a regular occurrence for residents of the town for centuries. The winter snows of 2009 and 2010 also afforded an opportunity to photograph some beautiful and, some might suggest, unusual scenes. Yet our weather forecasters predict that such extremes of weather may well be with us for the foreseeable future, so perhaps even these scenes may now be considered typical!

Tewkesbury was once one of the three most important towns in Gloucestershire, alongside Gloucester itself and Cirencester. It was already important enough for the Normans to build the hugely impressive church in the twelfth century, which still dominates the western part of the town today. The famous Y-shaped street design would have been established well beforehand, and today houses the great A38 trunk road which runs from Gloucester up Church Street and into the High Street towards the M50 motorway and onwards to Worcester. Meanwhile, the A438 runs from Ledbury before joining the A38 in the High Street before turning left into Barton Road then onwards towards Ashchurch and the M5 motorway.

The town remained a major commercial hub, dominated by the Abbey, before and after the Battle of Tewkesbury in 1471 which today is commemorated by the yearly Medieval Festival. Alongside the nationally-recognised Food Festival in the spring, this is one of several events that bring in visitors from the rest of Britain and abroad. It is from this late medieval period that many of the timber framed buildings for which the jown is justifiably famed originate. After the monastery at the Abbey was closed in 1540, the town continued to thrive. Abbey Mill, which can be viewed at the bottom of Mill Lane, was then the largest mill in the town and the Avon was diverted manually to serve this and several other businesses. The famous alleys developed as pressure increased to find new housing away from the main streets.

After a lull in the fortunes of the town, Tewkesbury became prosperous again in the Georgian era, which is why so many properties, particularly in the High Street, have either fashionable Georgian façades on top of original medieval properties, or were built new in the early 1800s. Around 1808, the Oldbury Field, which for centuries had provided agricultural land was enclosed by the town council to provide space for housing and businesses. Even though, as a result, the Industrial Revolution touched the eastern side of the town, Tewkesbury lost its importance as a commercial hub in the Victorian era, and so the town centre retained its charming, if rather schizophrenic medieval and Georgian character.

Despite some piecemeal and unsympathetic development over the 200 years since the enclosure of Oldbury Field, Tewkesbury has survived largely intact. Since the 1970s, the town has been a conservation area. Pleasure travellers on the Severn and Avon stop in Tewkesbury, as I had done before living here. Coach parties arrive on a regular basis from spring until autumn to visit the Abbey and stroll the town's streets. The Medieval Festival plus the Food and Mop Fairs bring in visitors from all over the region. As often happens, residents visit the nooks and crannies of their town less regularly than they should, so I hope that this book will help them explore a little further. To the visitor, I urge a few moments spent off the beaten path. The hidden treasures you discover will make your visit all the more worthwhile.

Stephen Lambe
October 2011

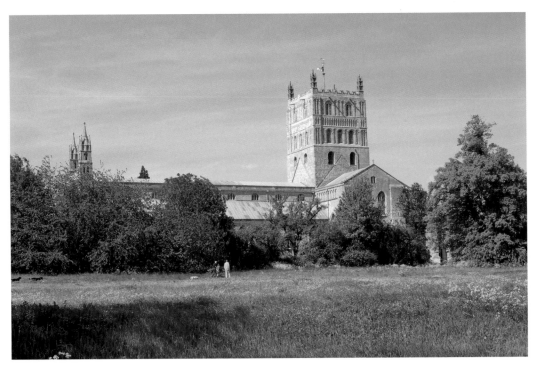

Tewkesbury Abbey from the Vineyards

What better way to begin the book than with several views of the Abbey, taken from the South on a bright spring day from beyond the tiny Swilgate river? Note the glorious display of wild flowers including cow parsley and buttercups on the meadow between the Abbey and the river.

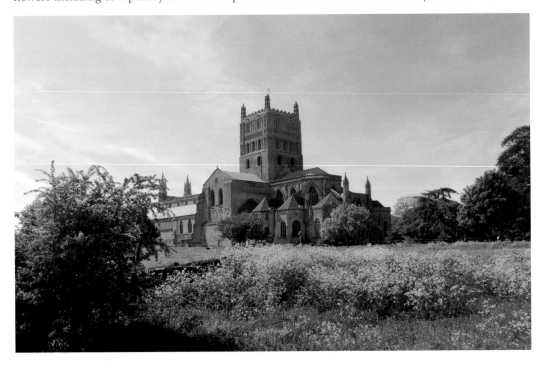

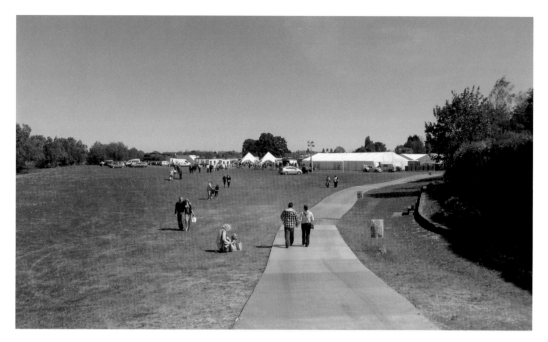

Tewkesbury Food and Drink Festival

Held every year over the early Spring Bank Holiday weekend, the Tewkesbury Food and Drink Festival, run by the Borough Council, mixes the best of local and regional produce with demonstrations from some of the biggest names in celebrity cooking. Initially a small affair on Abbey Lawn, a move to the Vineyards and an access point on Gloucester Road has allowed the event to grow considerably over the last few years. Visitors are here seen taking advantage of some excellent spring weather to enjoy some of the excellent food the Festival has to offer.

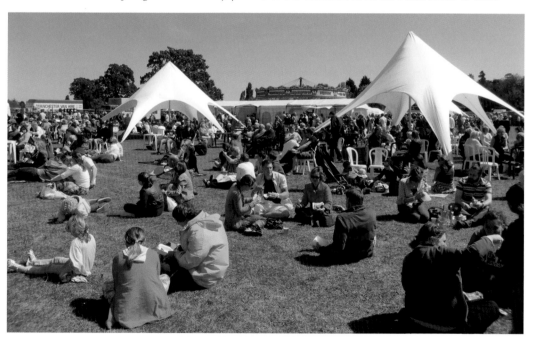

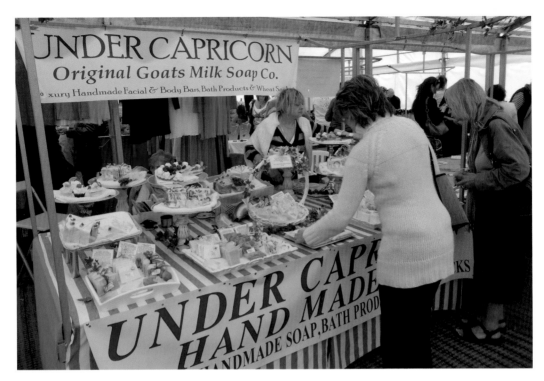

Tewkesbury Food and Drink Festival
An exhibitor demonstrates that local produce need not be about food and drink. Below is a display of local fruit juices, asparagus and tomatoes.

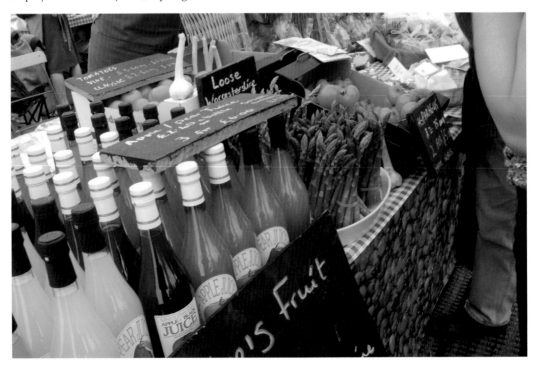

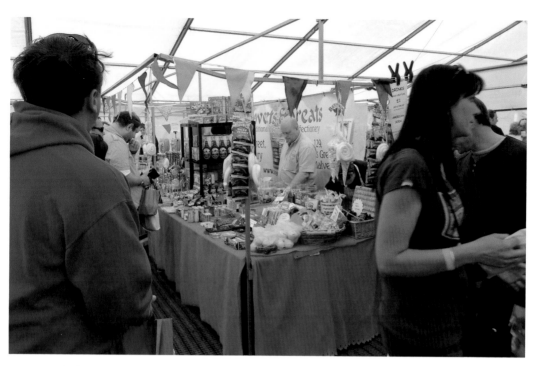

Tewkesbury Food and Drink Festival

Two exhibitors from very close to home. Sweets and Treats, one of the towns more entrepreneurial businesses at time of writing, display their wares at the Festival, while The Abbey Shop displays an array of gifts and local produce.

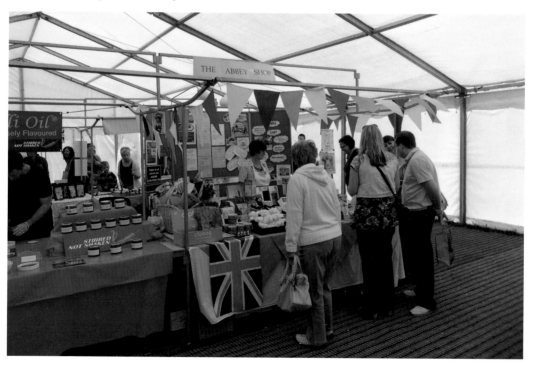

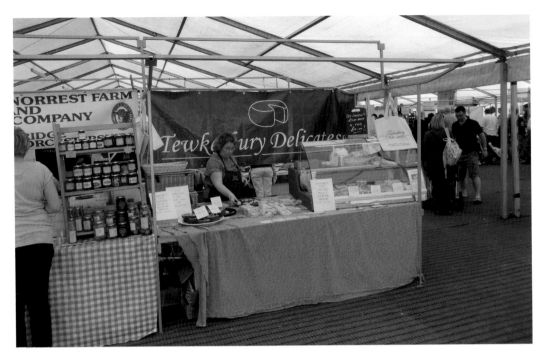

Tewkesbury Food and Drink Festival

Tewkesbury also has two fine delicatessens, 1471 in Church Street and the more recently established Tewkesbury Delicatessen, here pictured at the Festival. Below, chef Norman Musa shows off his skills in the demonstration theatre. Other celebrity chefs over the years have included James Martin, John Torode and Simon Rimmer.

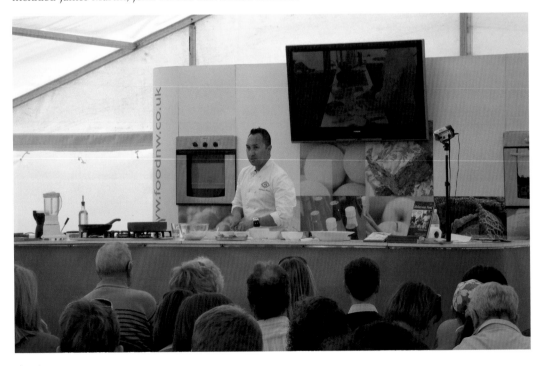

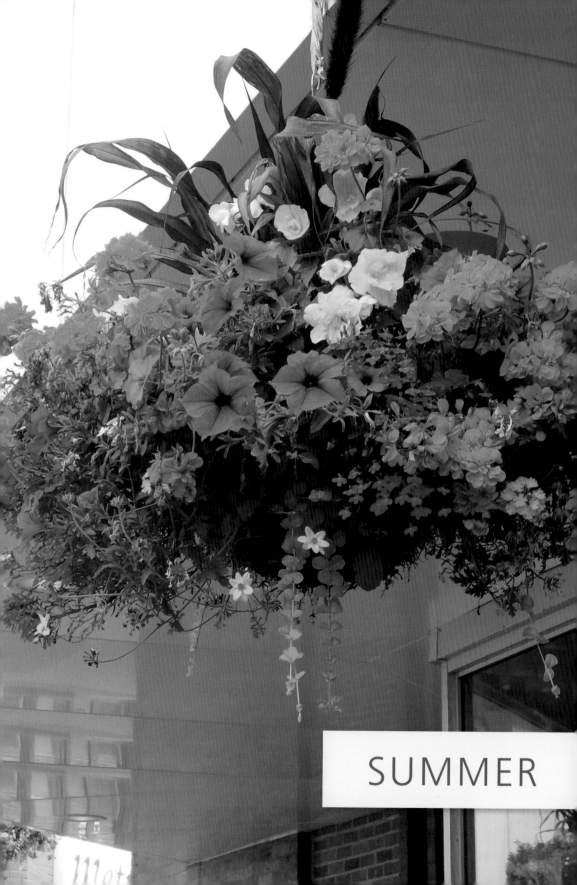

SUMMER

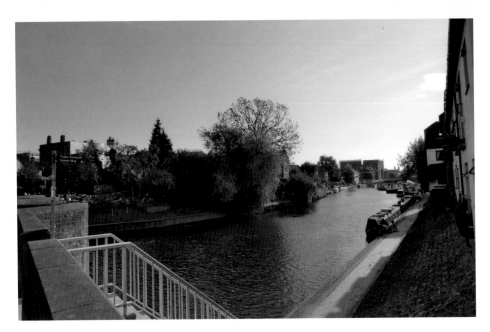

Mill Avon

Tewkesbury comes alive in the summer, and not least as a result of the pleasure craft and narrow boats using the Severn and Avon and mooring on Mill Avon. This glorious view above is from King John's Bridge looking south towards Lower Lode. Below, we have walked a couple of hundred yards down Mill Avon along the Severn Way. This photograph was taken looking back towards King John's Bridge. The bridge is supposed to have been built in stone at the order of the king himself in 1205, such was its importance to town communications in medieval times. Its importance has remained and it has been much altered and repaired since.

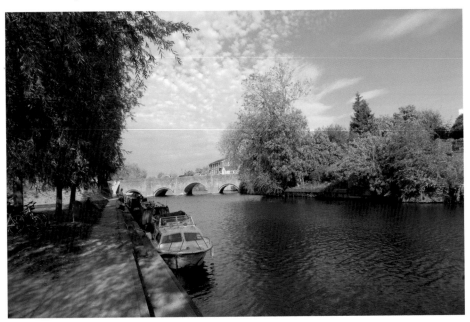

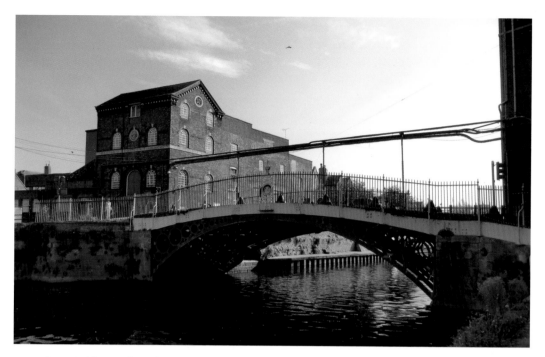

Quay Bridge and Healings Mill on Mill Avon

Pleasure craft navigating Mill Avon have to pass underneath the Quay Bridge, built in 1822, which replaced a previous sandstone structure. It is an attractive ironwork product of its time. Initially linking the quayside businesses, which at the time included a corn mill and a brewery, the warehouses on the town side of the river were built much later. Below, the *Tewkesbury Belle* pleasure craft can be seen continuing past Healings Mill and the gorgeous willow beyond.

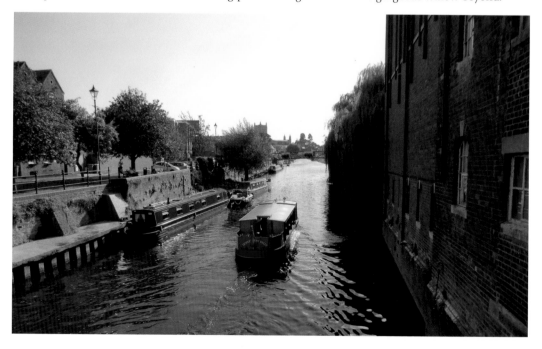

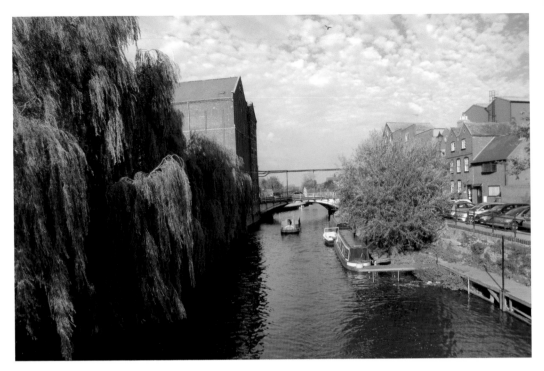

Mill Avon

The *Tewkesbury Belle* once again, this time photographed from the modern bridge a little way further down Mill Avon looking back towards Healings Mill, and below, looking back towards King John's Bridge from Healings Mill.

Both Ends of Mill Avon

Beyond King John's Bridge, the Avon and the Boathouse pub is *Tewkesbury Marina*, here shown in the distance. The bridge in the distance seems to have little purpose. In fact, built in 1864 it is a relic of the Tewkesbury to Malvern branch line before its closure by Dr. Beeching in 1961. At the other end of Mill Avon is Abbey Mill. In 1865 the mill employed seventeen men and thirteen women. The mill was still in operation into the twentieth century but by 1933 had become a café.

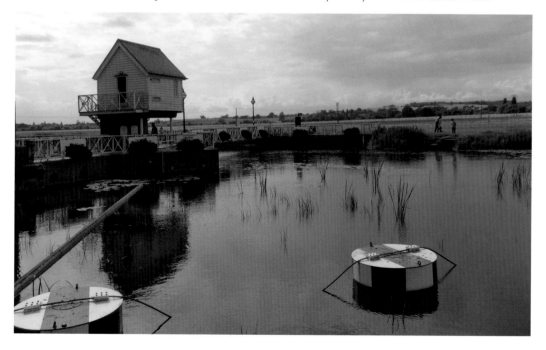

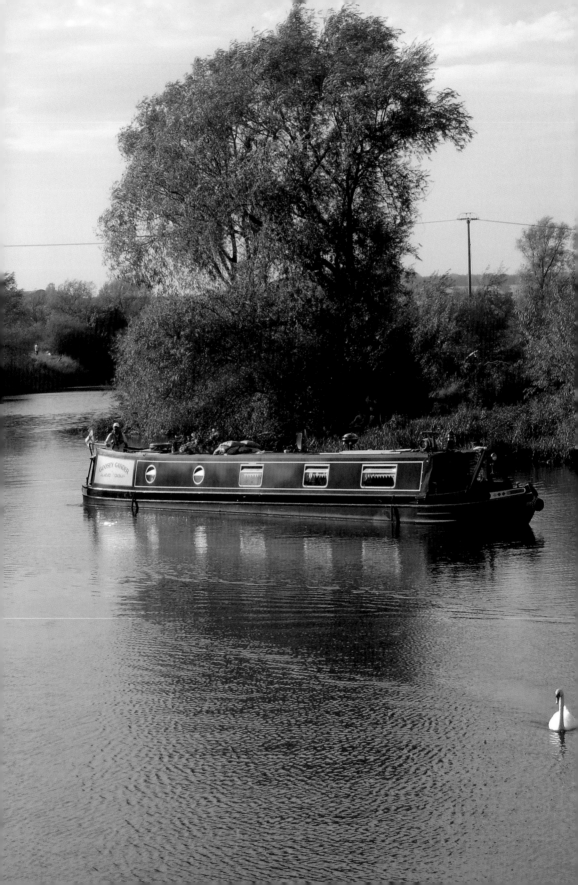

More Avon and Mill Avon Views

A narrowboat is seen opposite as it travels down the main Avon running parallel to Mill Avon. The two photographs on this page show how beautifully the hanging baskets, organised by Tewkesbury in Bloom and sponsored by local companies, enhance Mill Avon during the summer months.

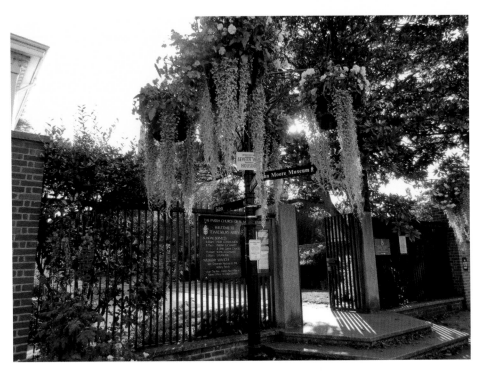

Two Entrances to Tewkesbury Abbey

These two adjacent entrances to the Abbey grounds are also enhanced by the town's smart signposts and quite spectacular hanging baskets. Note also the handsome medieval building on the corner of the Crescent, one of many in the town converted to office use.

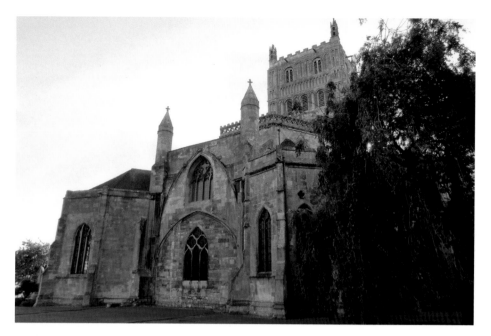

Tewkesbury Abbey

The Eastern approach to Tewkesbury Abbey is the least spectacular and therefore the least photographed of views, yet still deserves attention. Working around the Abbey, the Norman Tower comes into proper view. The Abbey was almost complete in 1121 when it was consecrated. It was originally built to house Benedictine monks. Further alterations to the long nave and chancel were made in the fourteenth century. When Henry VIII dissolved the monastery in 1540, many of the surrounding buildings were demolished or seized, but the church itself was saved as the local parishioners argued that they needed somewhere to worship. They purchased it for £453.

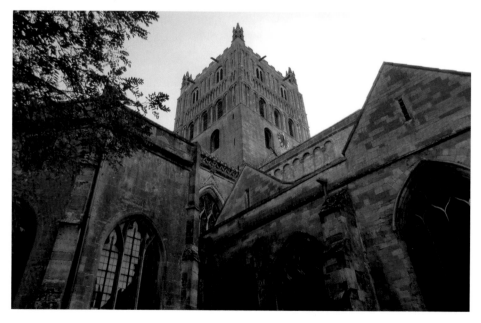

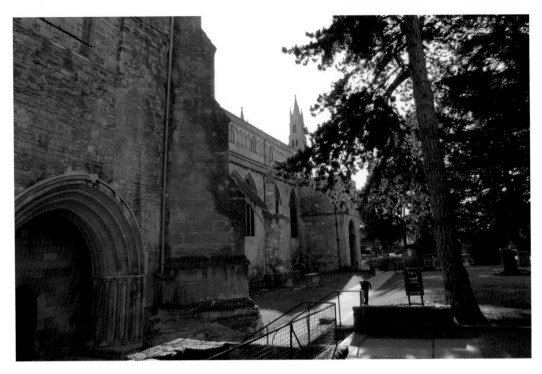

Tewkesbury Abbey – Northern Side

Moving round the Abbey to the north, we reach the main entrance, and enter the spruce tree dominated grounds between Church Street and the main Abbey itself.

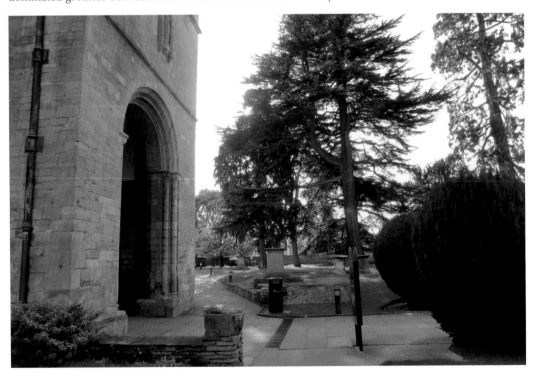

Tewkesbury Abbey Grounds

With its sheltered benches and ornate tombstones, the Abbey grounds are a secluded and peaceful place to sit at any time of year. One particular tomb is of particular historical significance. It is the tomb of Samuel Healing, son of the famous Samuel Healing, founder of Healings Mill and an important figure in the early Victorian era. His son died tragically young at the age of nineteen in 1848. The vault also includes the remains of the boy's mother Mary who died in 1862 aged sixty-two.

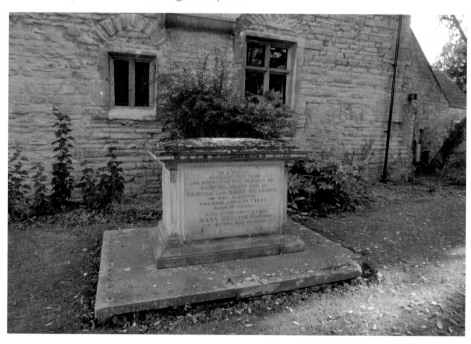

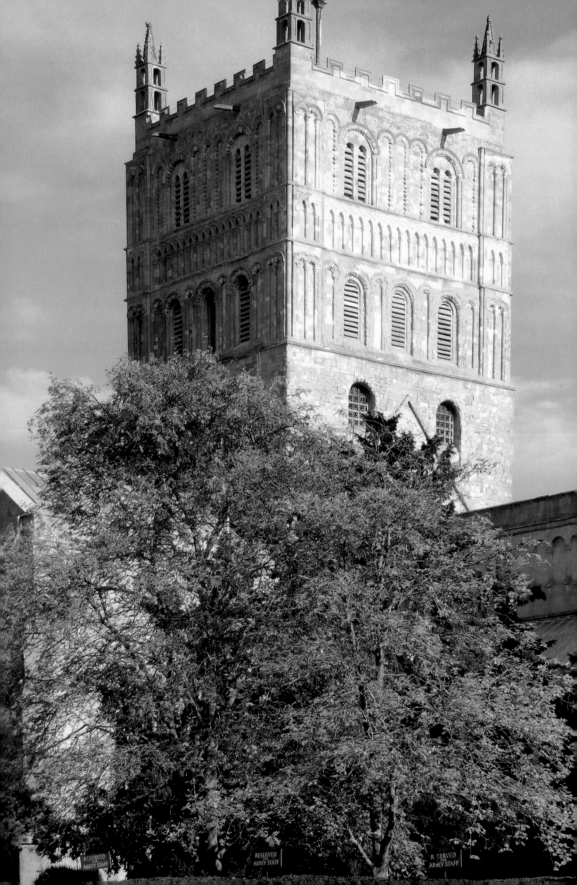

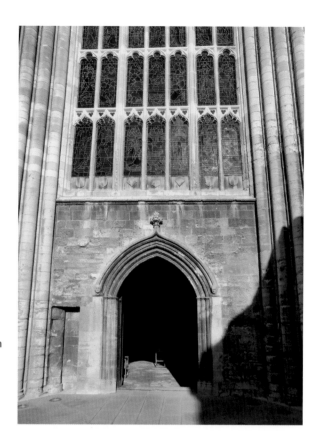

Tewkesbury Abbey – Western Archway

These two views show the magnificent western archway of the Abbey, the largest external arch in the country.

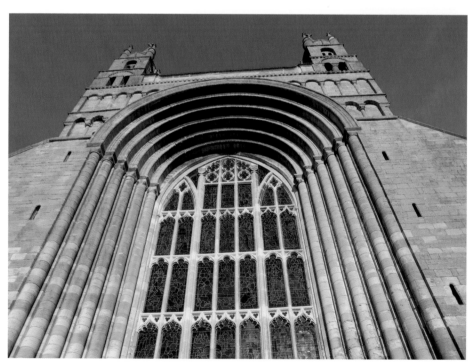

Abbey House
This grand residence was originally given
to the Abbot of Tewkesbury. The house was
given a brick frontice in the nineteenth
century, and is now the Vicarage.

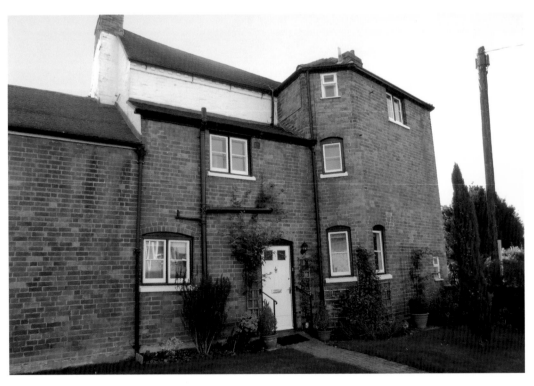

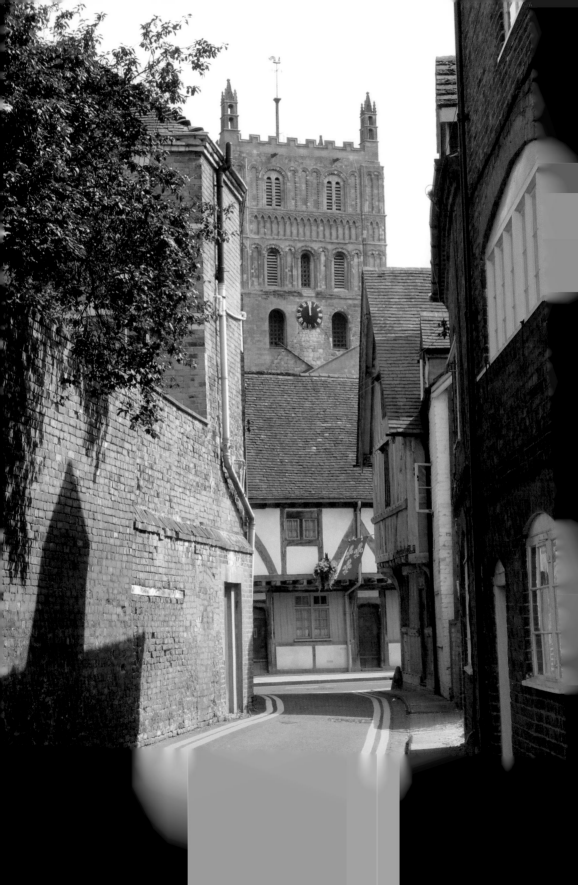

Around the Abbey
The magnificent Norman tower (previous page) as it can be seen from many vantage points around Church Street. The Swilgate river, left, as it wanders from the Abbey towards Tewkesbury Hospital and below, looking across the Abbey grounds and the vineyards.
The fence shows the end of the Abbey-owned land.

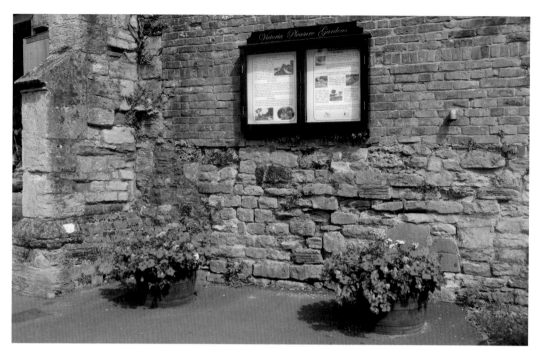

Victoria Pleasure Gardens

First created by public subscription in 1897, Victoria Pleasure Gardens was a popular leisure location for the people of Tewkesbury, particularly during the Edwardian era. Like many such gardens, lack of funding lead to falling maintenance standards and the floods in 2007 devastated the gardens completely. The photograph below looks towards Abbey Mill in summer.

The Mill Street Entrance from Both Sides

Above, looking out of the gardens towards Mill Bank Cottages opposite. The building on the right was once a barn, then became a malt house and is now made up of offices. Below all the gardens from the entrance are shown with the lovely willow in the background.

Planting in Victoria Pleasure Gardens

That the gardens now look wonderful is down largely to the Friends of Victoria Gardens who have tried to copy the original planting from the late Victorian era. The gardens are planted and maintained from June to October.

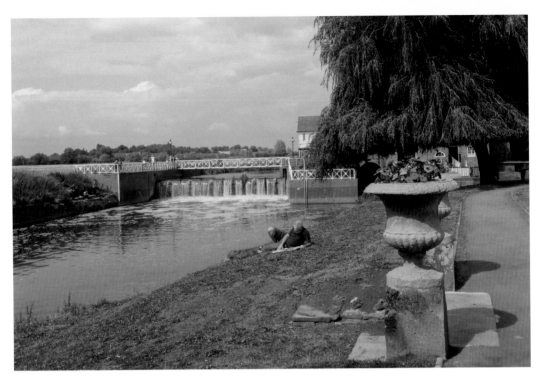

Looking Towards Abbey Mill Weir

Two charming views of the weir and flood defences at Abbey Mill taken from Victoria Pleasure Gardens.

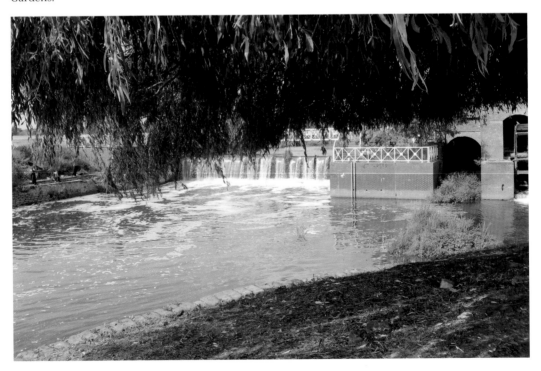

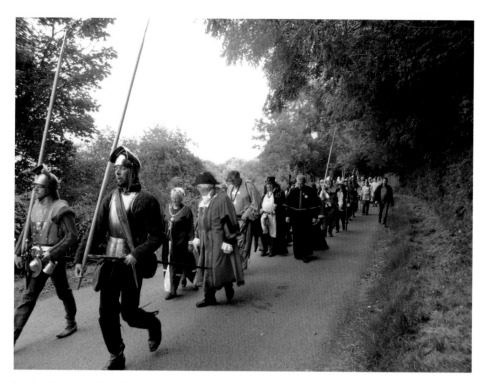

Tewkesbury Medieval Festival – Opening Ceremony

The Colchester Watch escort the Tewkesbury Town Mayor and other local dignitaries to the opening of the Medieval Festival, the largest Medieval Fayre in Europe. Patron of the Festival is actor and longbow expert Robert Hardy, shown below delivering a stirringly appropriate speech from Shakespeare's *Henry V*. Other patrons include Blackmore's Night, the medieval musical group led by former Deep Purple rock star Ritchie Blackmore.

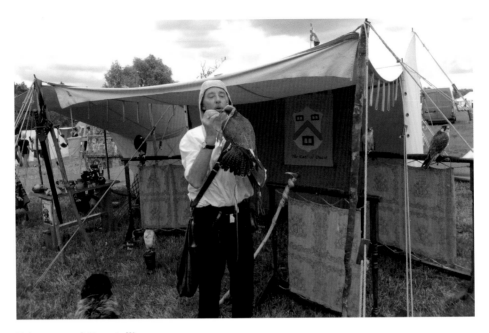

Falconry and Storytelling

While the Medieval Festival is best known for its battle re-enactment, it also hosts dozens of stalls and other entertainments. Here, the noble art of Hawking (or Falconry) which in medieval times was an efficient method of hunting and sport is, if not demonstrated exactly, discussed. Storytelling (below) is also an art that has become less important these days in our world of instant communication. In medieval times, it was a vital way of passing on folklore and oral history.

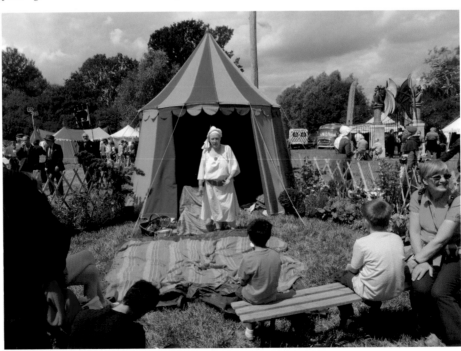

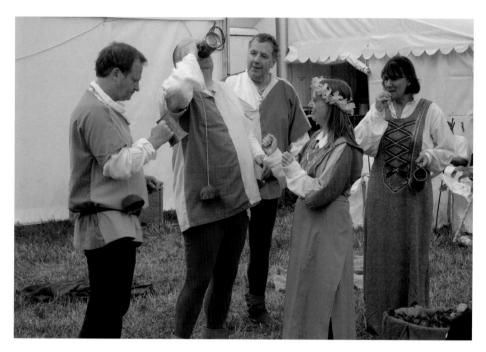

Mummers and Armour Displays

As opposed to storytelling, Mummers were groups of actors travelling from, most often, public house to public house, acting out stories and plays. Some, including the tale being acted out in this picture, were bawdy in nature! With battle re-enactment an industry in its own right, stalls like the one pictured below are very common at the Medieval Festival, crammed with replica weapons and armour.

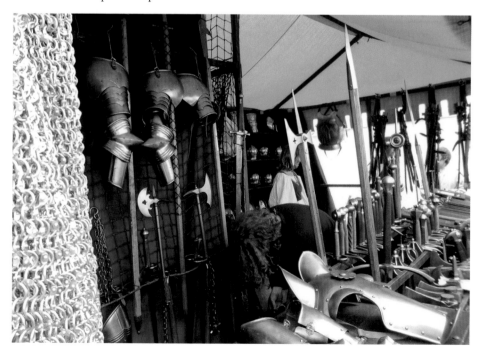

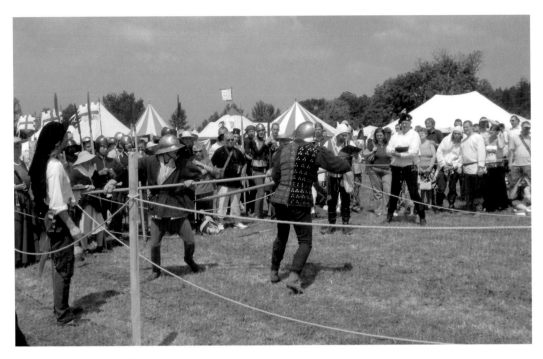

Battles – Big and Small

As well as the main battle re-enactment, it is also possible to view combat at close quarters via one-to-one battles like these, which shows two pikers battling to a mixed audience of Festival visitors and re-enactors. However, it is the two re-enactments themselves that draw the biggest crowds. The Wars of the Roses were not like the English Civil War, where constant warfare was an everyday reality. These were sporadic and complex affairs between the House of York, led by Edward IV and the Lancastrian Henry VI (although at the time he was imprisoned in the Tower of London), his wife Margaret of Anjou and their son Edward.

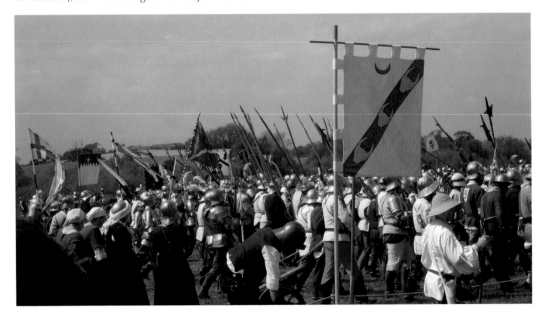

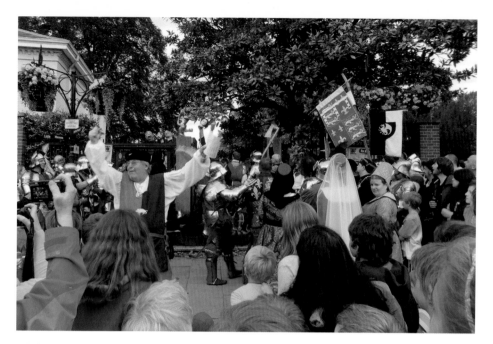

Trial and Execution

The battle did not go well for the Lancastrians, and Edward and his men were all killed on the battlefield or executed shortly afterwards. On the Saturday evening of the Festival, the re-enactors re-live the storming of the Abbey, where some of the Lancastrians were hiding, followed by their trial and execution. These events are re-enacted with a mixture of reverence and knowing irony. In the top picture, Tewkesbury's Town Crier leads the audience in shouts of "May they rot in the bowels of hell", as each mock execution takes place. In the bottom picture, Edward addresses the crowd before his own demise.

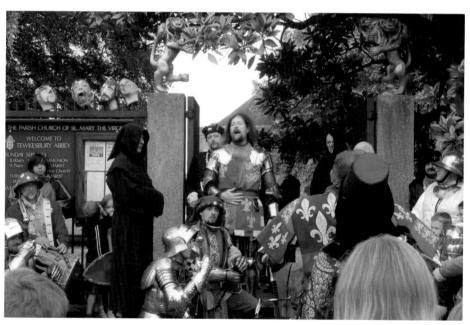

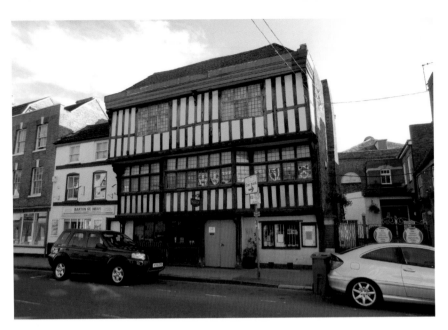

Two Museums

This glorious medieval building houses Tewkesbury Town Museum in Barton Street. It holds many important artefacts from Tewkesbury's past, including the model village that used to be housed in the Rose Garden behind the Town Hall. Nestled in a row of historic timber-framed buildings in Church Street, the John Moore museum was established in 1980 in memory of the local writer and naturalist. Today it is also home to an extensive natural history collection featuring specimens of the mammals and birds native to the UK. A few doors away is The Merchant's House, a two-storey building which has been beautifully restored and furnished to show the construction of a fifteenth-century shop and dwelling.

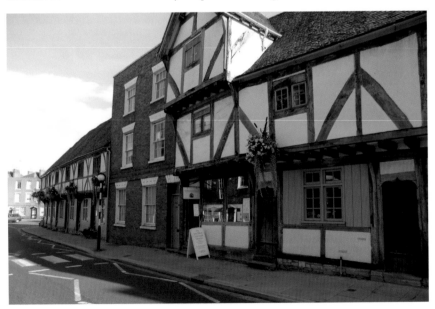

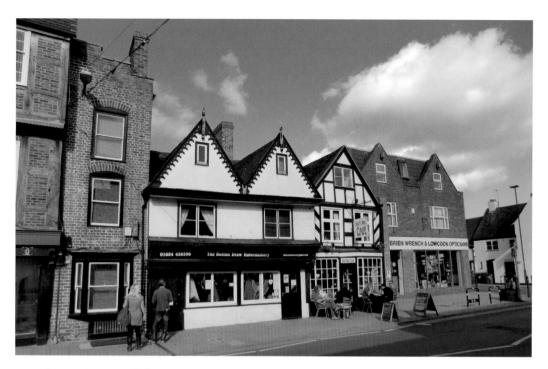

Barton Street Buildings

While the interesting buildings are spaced a little further apart than in Church Street, Barton Street still has its fair share of fine medieval buildings, as shown here. Tewkesbury was also very prosperous in the Georgian and early Victorian era, as shown by this pair of splendid town houses on the corner with Chance Street, just a short walk from the High Street.

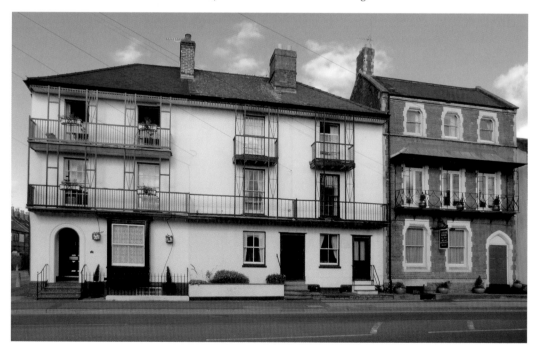

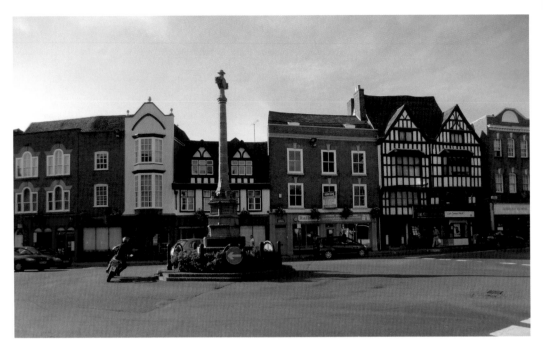

The Cross

Here we have two views of The Cross from different angles. The top looks across from Barton Street, while the bottom view is a little further along towards Church Street, and looks up the High Street. The Cross, now a war memorial, is on the site of the centre of Tewkesbury's ancient market, where a Tolsey stood (a tollgate and meeting hall for merchants). Tolsey Street, now the site of an antiques market, lies over the road on the corner of High Street and Church Street.

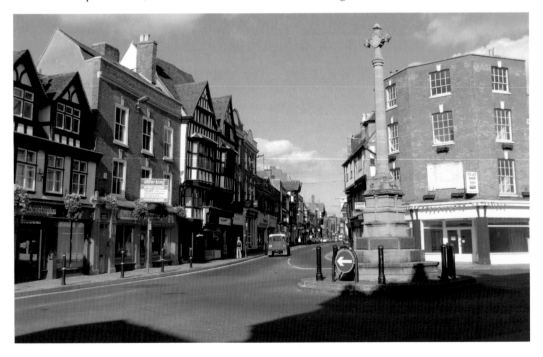

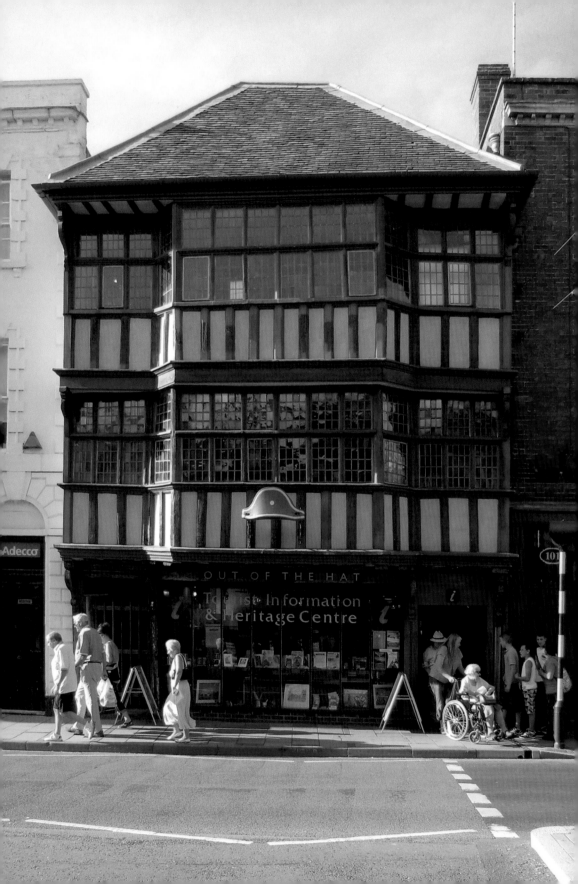

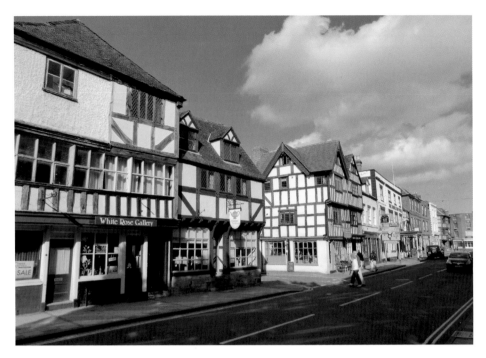

Church Street Buildings

Tewkesbury's Tourist Information Centre (previous page) is now housed in the newly-refurbished Old Hat Shop, now called Out of the Hat. The upper floor of this restored seventeenth-century building features interactive displays of what it was like to live in Tewkesbury almost 500 years ago. Church Street houses the best concentration of medieval buildings in the town, as can be seen above and below.

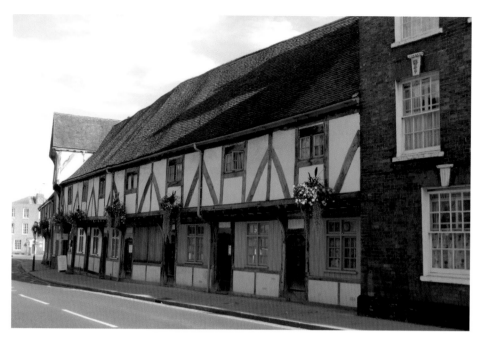

Church Street Buildings

The stunning Abbey Cottages in Church Street were originally built in the fifteenth century by the Abbey as shops. By the 1960s they had fallen into decay but were restored to a high standard by the Abbey Lawn Trust between 1967 and 1971. The Little Museum within the row has been restored to give an impression of what one of the shops might have been like. Another impressive row of properties is below, showing off the flags that can be seen throughout the summer. This row includes the Berkeley Arms pub, and J. W. Jennings, the rug shop first established in 1960.

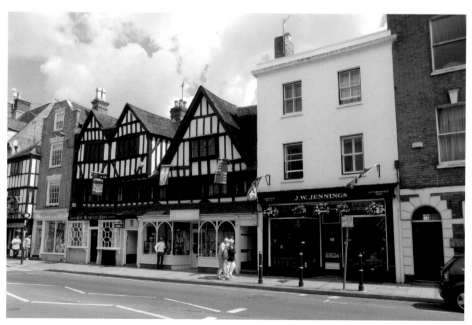

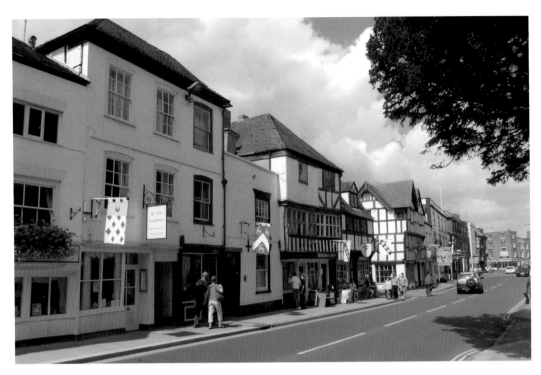

Church Street Buildings

More impressive Church Street buildings. The lower photograph shows off the finest floral display in the town during the summer, on the top end of the Crescent.

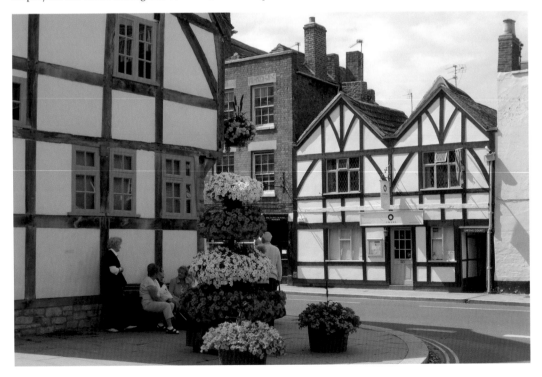

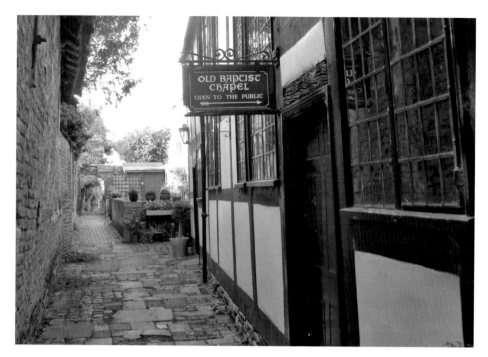

Nooks and Crannies

The Old Baptist Chapel was the meeting house of the Baptist Church in Tewkesbury. In 1655 it was known to have 120 members. During the Cromwellian era, groups such as the Baptists were given relative freedom, but were persecuted in the 1660s. The Act of Uniformity of 1662, for instance, required every church to follow the Anglican *Book of Common Prayer*. The chapel is open to the public and viewings can be booked via Out of the Hat. The Old Chandlery (below) in St Mary's Street, is now a residence but served boats on Mill Avon for many years.

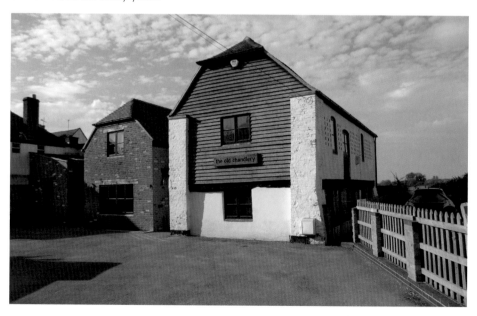

Mill Street Cottages
The Corner of Mill Street and Church Street is captured above. Below, chocolate-box cottages in Mill Street.

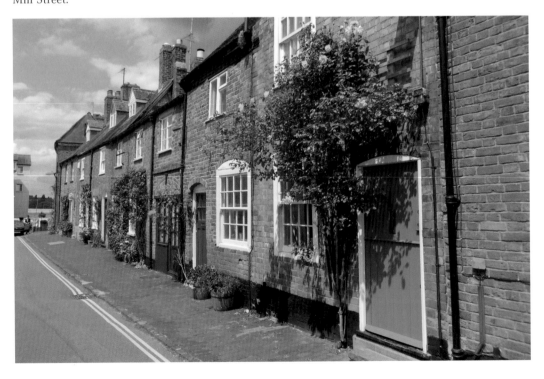

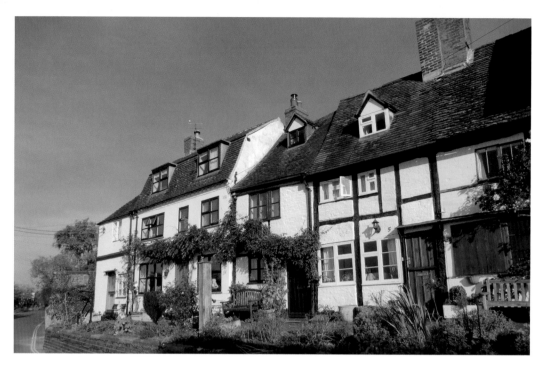

Mill Bank and St Mary's Lane Cottages

These much photographed cottages are among the finest in Tewkesbury. Built around 1500, they are further demonstrations of the power of the Abbey within the town. Further cottages in St Mary's Lane including Crumpets café can be seen below.

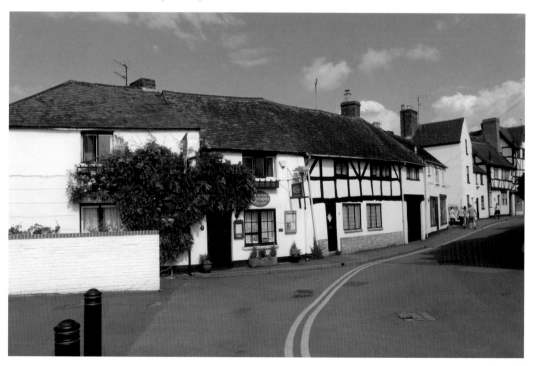

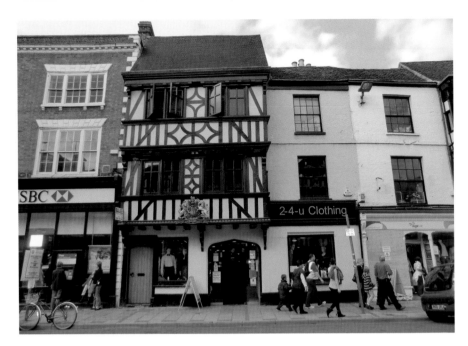

High Street Buildings

Tewkesbury has been a conservation area since the 1970s, which has helped preserve the faintly old-fashioned nature of its specialist shopping. With companies unable to knock properties through into larger buildings, few large chains have come into the town. Nonetheless, the town's retail range remains surprisingly varied, with two excellent butcher's and some fine clothes shops, including 2-4-U in the High Street. These ornate frontages have a striking, almost Eastern feel, yet add to the charm of the High Street shops.

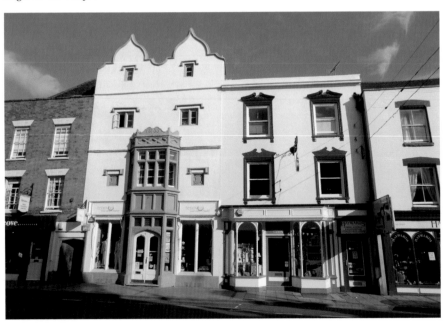

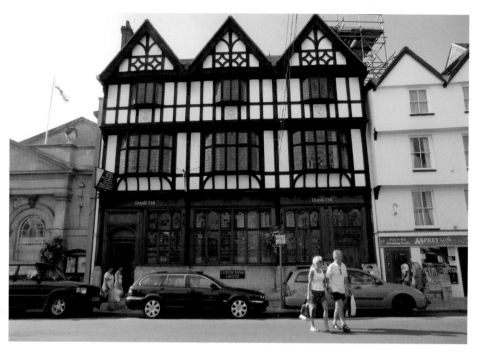

High Street Buildings

The ornate splendour of Lloyds Bank contrasts with the neo-classical pretentions of the Town Hall, photographed at night. The original frontage can be found inside the hall, where room was made for the indoor Corn Market. As well as housing the Town Council, the Corn Exchange hosts various markets throughout the year.

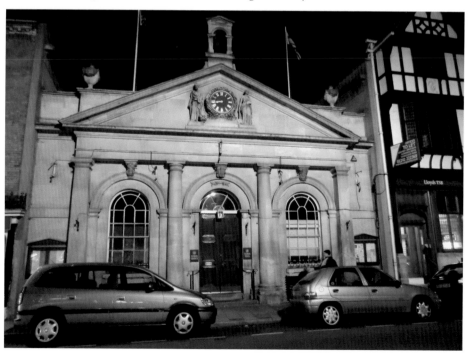

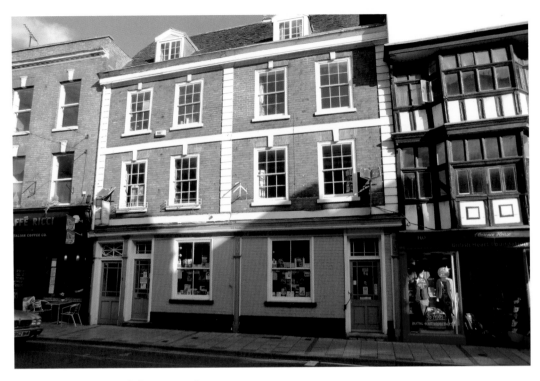

Alison's Bookshop and the Roses Theatre
One excellent reason to visit Tewkesbury is Alison's Bookshop, perhaps the finest independent bookshop in Gloucestershire. Full of wonderful nooks and crannies, it also contains a Music Room. Built in the mid seventies, the 400-seat Roses Theatre is another jewel in Tewkesbury's crown, hosting theatre, concerts and, of course, its pantomime over the Christmas period. Opposite, flags and flowers at the bottom of the High Street.

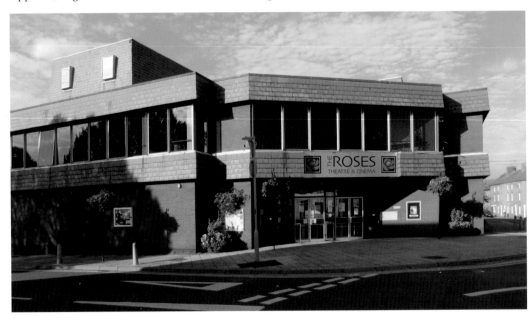

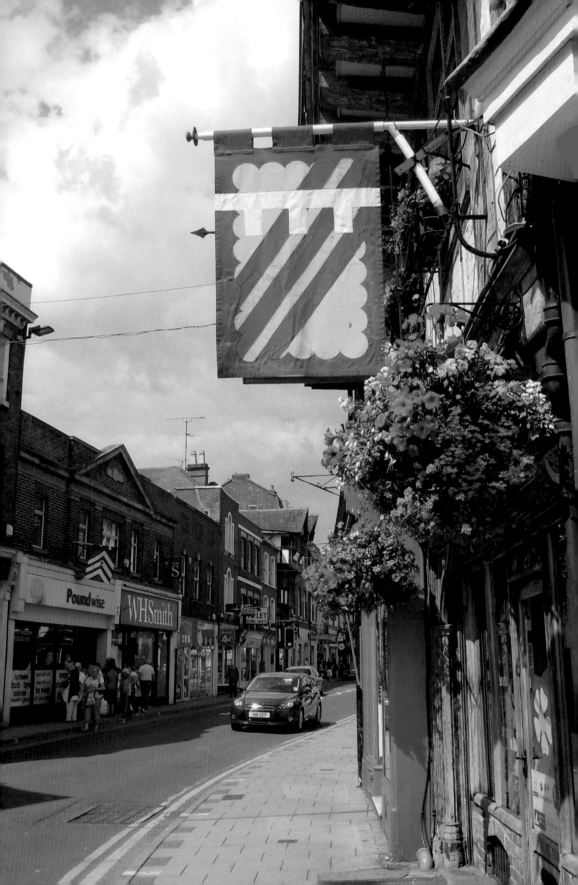

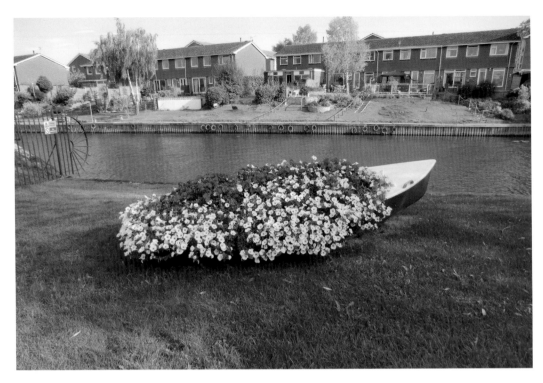

Making the Best Out of Disused Boats

Given the links the town has with its two rivers, what better way to use old boats during the summer than to fill them with flowers?

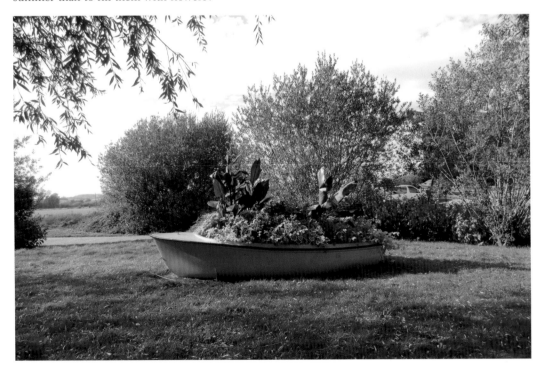

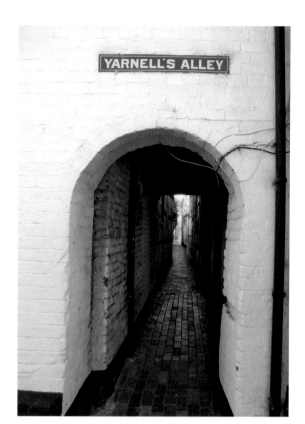

Tewkesbury Alleys

The entrance to Yarnell's Alley in Barton Street (right), a typical alley in the town, built as an inventive way of providing access to more accommodation behind the main streets. Many of these provide interesting cut-throughs or are worth exploring for other reasons as shown by this row of sympathetically-built new cottages at the bottom of Machine Court off the High Street.

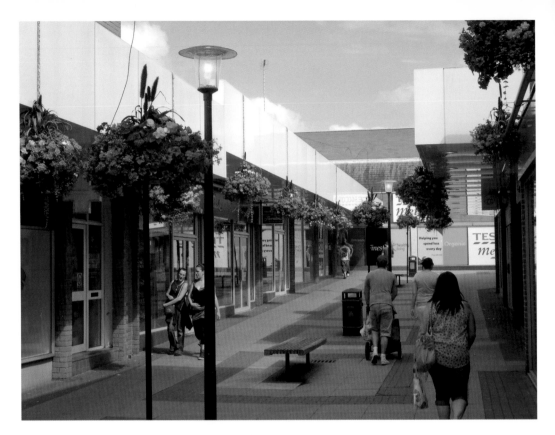

Bishop's Walk in Bloom
The somewhat brutalist
architecture of Tewkesbury's
modern, though thankfully
small, shopping precinct
housing Boots and Tesco
is given special attention
during the summer, and
these hanging baskets
completely transform
the area with spectacular
displays, particularly on a
sunny day.

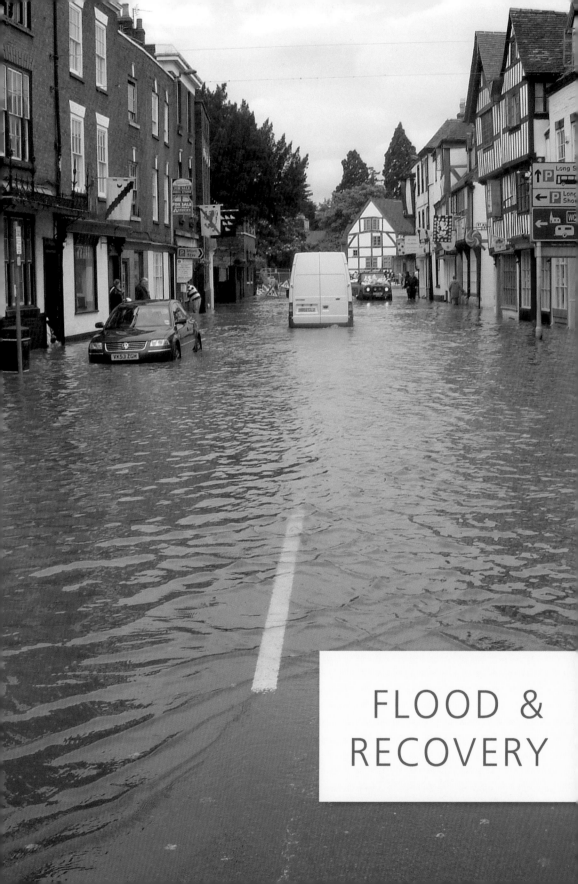

FLOOD &
RECOVERY

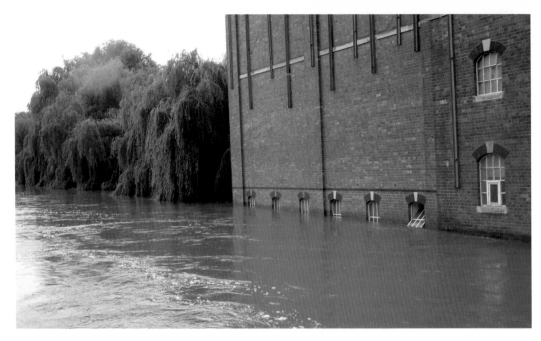

Healings Mill

On Friday 20 July 2007 it rained all day. This was not a traditional English summer rain but a torrential monsoon-like downpour. Flash flooding was the first problem, and many shops closed early. Overnight it appeared that the problems were more serious than was first thought. Helicopters hovered overhead rescuing those already stranded by the rising waters. These two photographs show the impact of the rising Mill Avon at Healings Mill, where an image from 2007 is contrasted with a much more normal scene taken in early autumn.

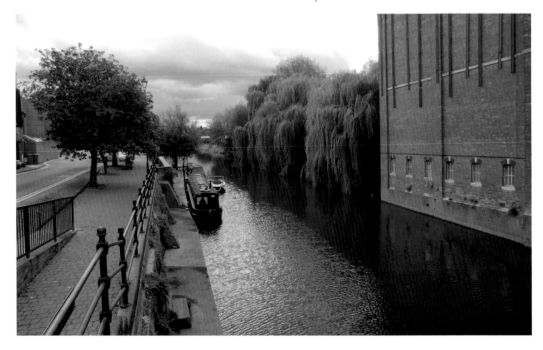

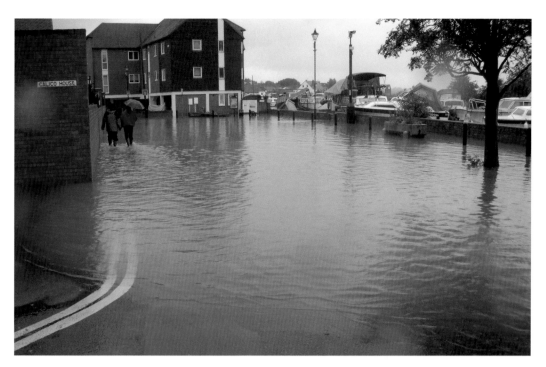

Back of Avon

Until lunchtime on Saturday 21st the town was still accessible via King John and Mythe bridges, but later that day the police closed this entrance and the town was effectively cut off. These photographs of Back of Avon show the extent of the flooding.

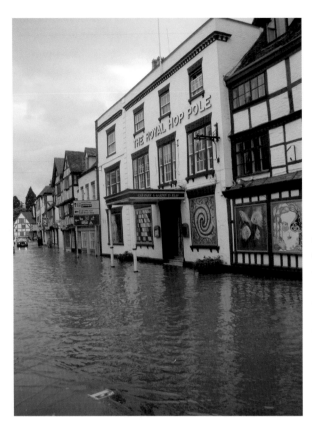

The Royal Hop Pole, Church Street
The traders worst affected by the floods were those in Church Street, many of whom were forced to leave their own premises for months. Here we see one of the iconic buildings of Tewkesbury, the Royal Hop Pole Hotel. This seventeenth-century inn was disused in 2007, and was handsomely converted to a Weatherspoon's pub and hotel during 2008.

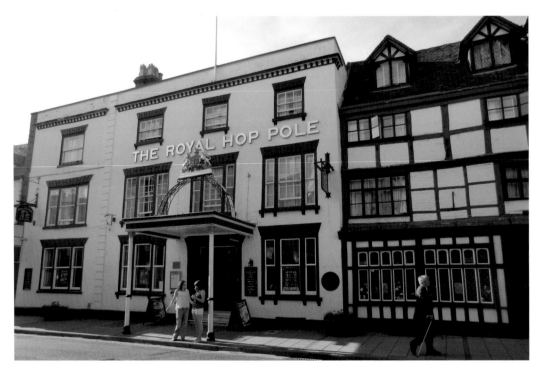

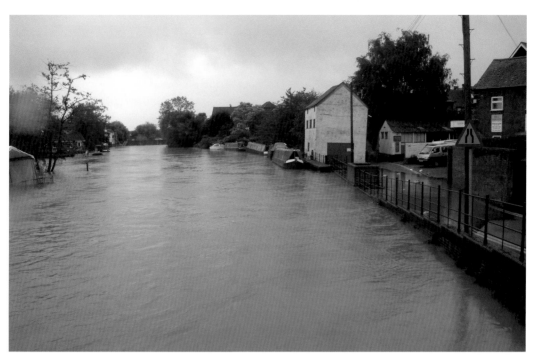

Mill Avon, Looking Back Towards King John Bridge
The flooding in 2007 rose so high that the moorings in the left hand bank were completely submerged. Note also the two new windows in the refurbished white and brown building in the lower picture.

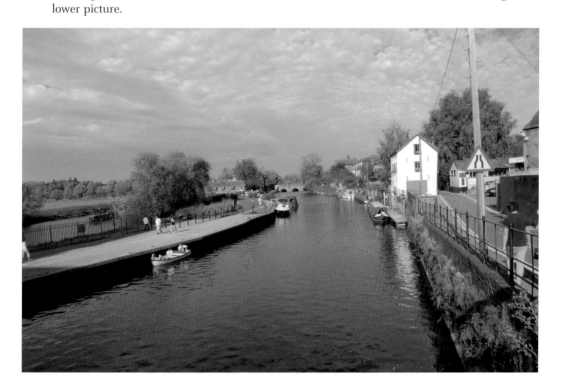

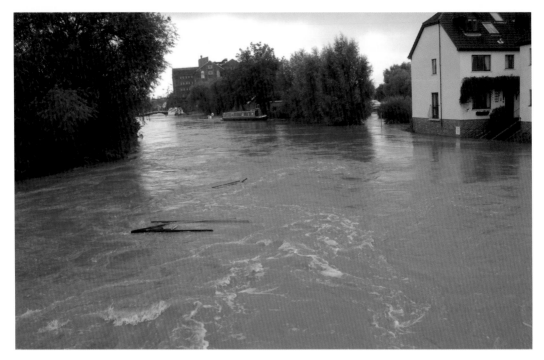

View from King Johns Bridge Towards Healings Mill

The Severn and Avon Rivers did not reach their height until Sunday 22nd, when flood waters higher up both rivers finally reached Tewkesbury. Debris became a hazard as shown in the upper picture. The lower picture shows the view as it is now. Note the blue narrowboat in exactly the same position in both photographs. People do not give up their moorings easily!

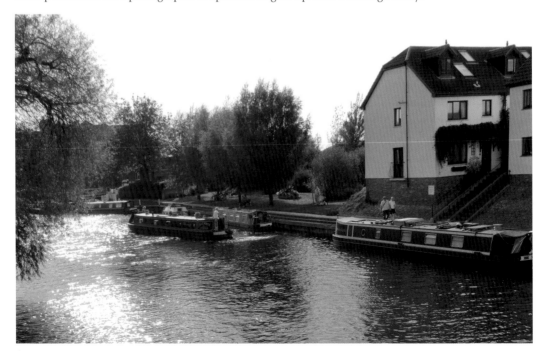

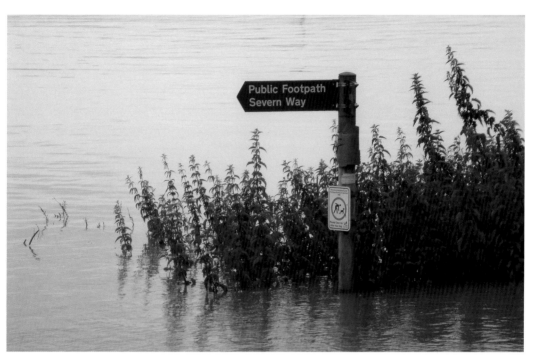

Public Footpath Sign, near King John's Bridge
Amazingly, this is the same sign. Almost submerged in 2007, it signposts the Severn Way which cuts along the Avon next to the Severn Ham. Often flooded in winter, the Ham will rarely have been in this state in July.

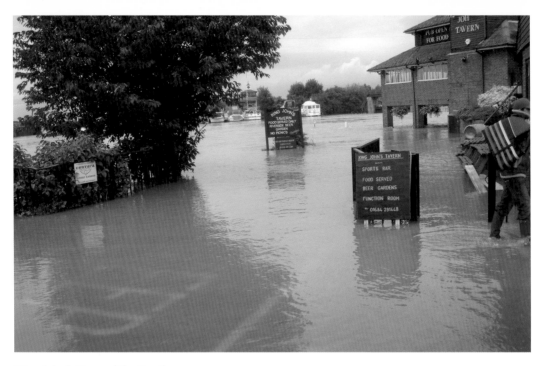

King John's Tavern/The Boathouse

This modern pub and the northern end of town was, not surprisingly, an early victim of the flooded Avon. It has since changed its name to The Boathouse.

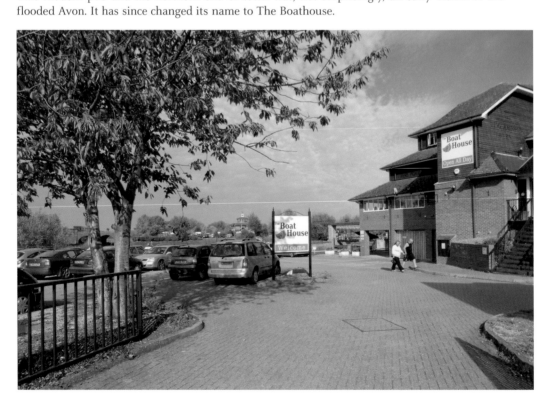

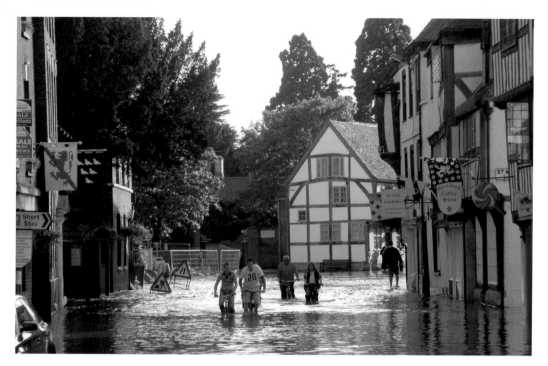

Church Street

This is my favourite image of the floods. On Sunday evening (July 22nd) the waters stopped rising and the sun came out. This photograph shows the lower end of Church Street as, rather charmingly, four cyclists ride through the floodwater. The picture below shows Church Street on a more typical Sunday afternoon in mid October.

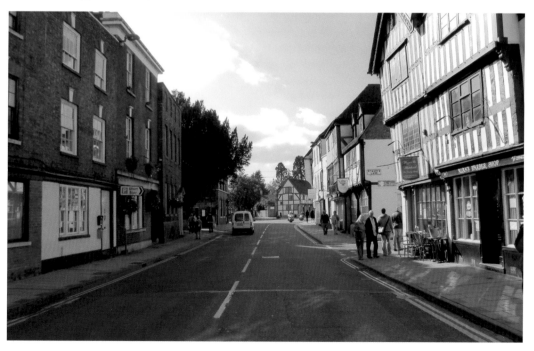

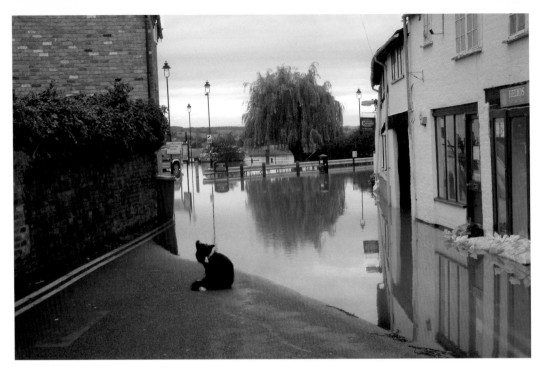

Shops in St Mary's Lane

The medieval buildings on the right suffered badly in the floods. Crumbs café, at the end of the row, reopened in 2008, but the property closer to the camera has remained empty since 2007. A lone dog adds to the air of melancholy.

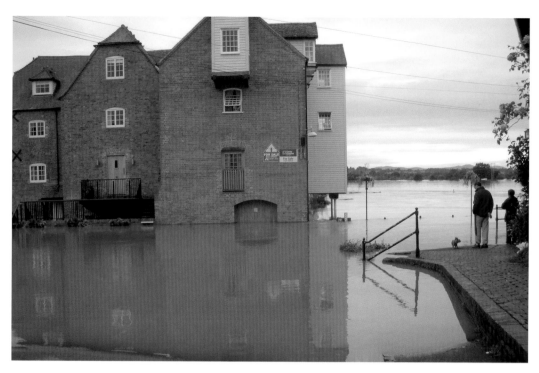

Abbey Mill from Mill Lane

So much for the flood defences! The newer photograph shows a distinct tide mark from a past flood, although careful observers will spot that the 2007 flood rose way beyond that level.

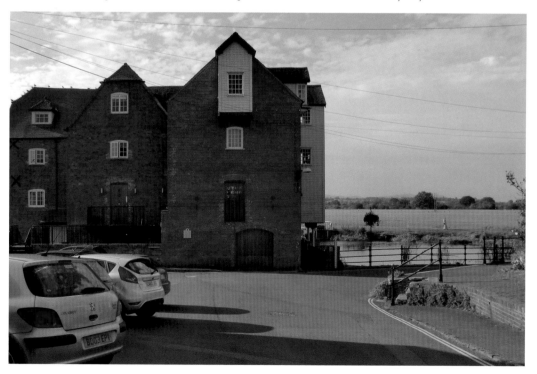

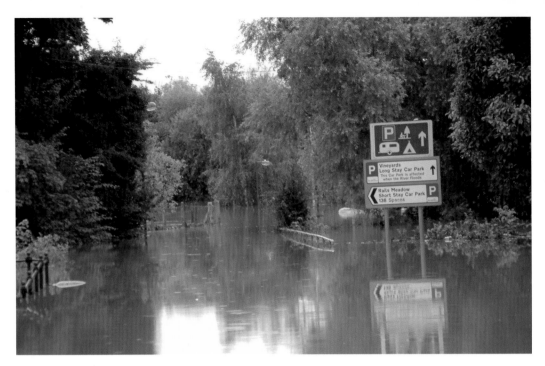

Approach to Vineyards Car Park

As with Page 59, the position of signage helps us appreciate how high the flooding was. This photograph appears to show a lake, but no, it is just an ordinary road beside the Abbey leading into a car park, as shown in the lower picture.

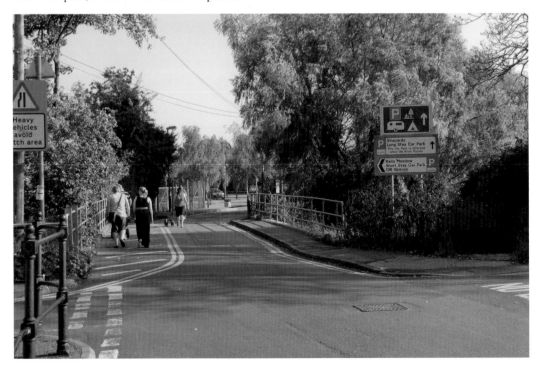

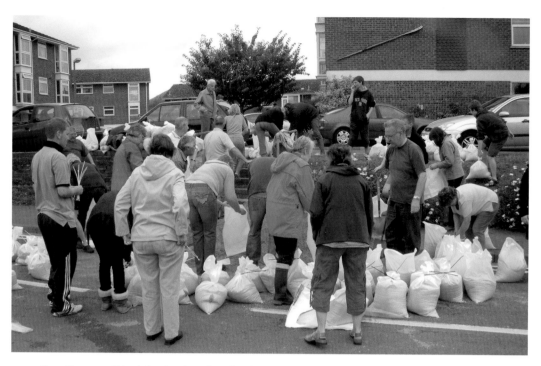

Two Scenes of Activity During the Floods

Residents collect sandbags on the Bredon Road (above) and rescuers relax for a moment in a flooded Morrisons car park (below). Overall, the flooding was at its most devastating along the Ashchurch Road, where dozens of residences were flooded. Some did not move back into their houses for nearly two years.

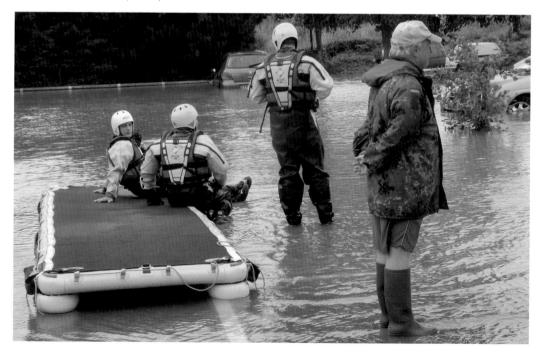

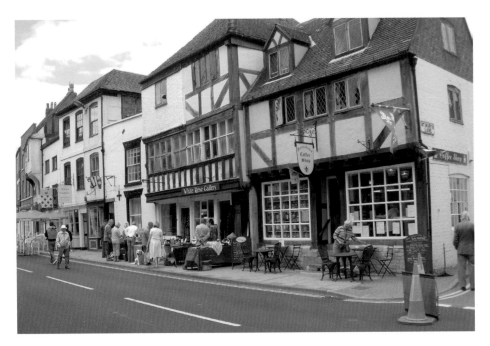

Recovery July 20–21 2008

The iconic aerial photograph of a flooded Tewkesbury haunted the people of the town for a further year. When the rivers again breached their banks in January of 2008, the press once again screamed "Tewkesbury Flooded!". In fact, this time it was normal seasonal flooding, and the floodplains did their job. The roads remained open. Frustrated by this unfortunate coverage, a celebration was planned on the first anniversary of the floods, as shown in the next few pages. With Gloucester Road closed on the Sunday, we were given a glimpse of a possibly Mediterranean alternative reality, with cafés spilling onto the streets, and traders doing likewise as shown in these two photographs.

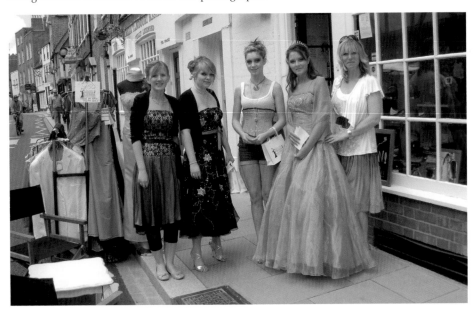

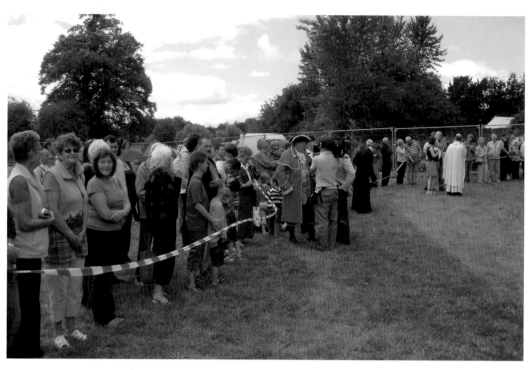

Joining Hands Around Tewkesbury Abbey

Another feature of the weekend was an attempt to banish the much-hated aerial photograph with something much more positive, an image of people linking arms around the Abbey. These two pictures show this in progress.

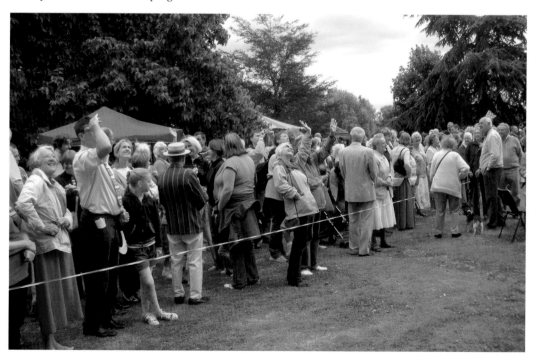

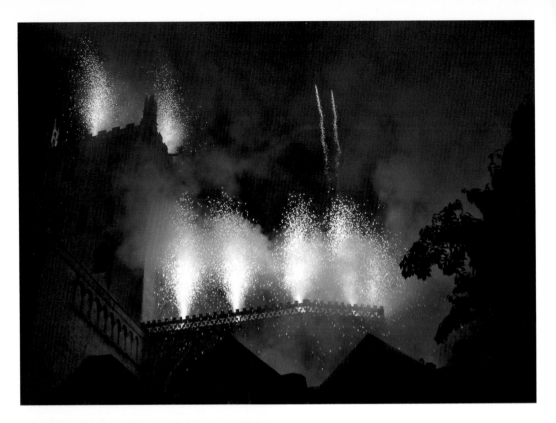

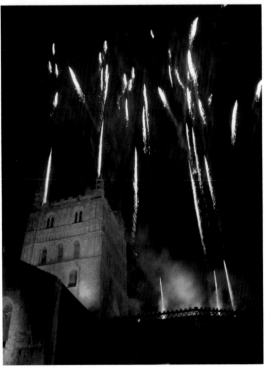

Fireworks at the Abbey
Finally, a rock concert and fireworks display was organised for the Abbey grounds. These two photographs show the fireworks display, spectacular against the backdrop of the Abbey itself.

AUTUMN

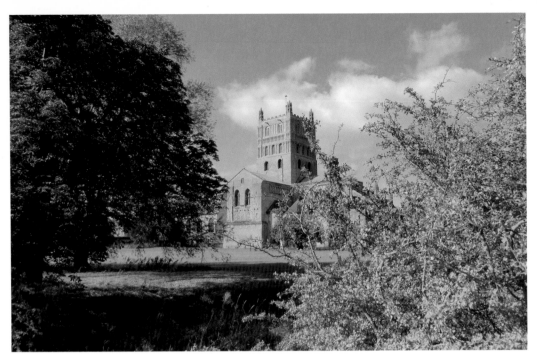

The Abbey and Abbey Mill

A great shot of the Abbey from the Vineyards, shot through autumnal bushes along the Swilgate river. Below, another clear shot, this time of Abbey Mill and weir, showing the flood defences, taken from Victoria Pleasure gardens.

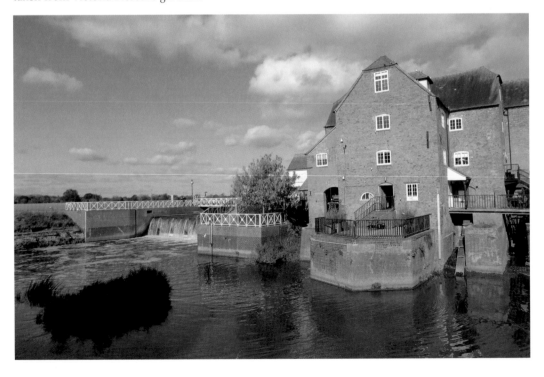

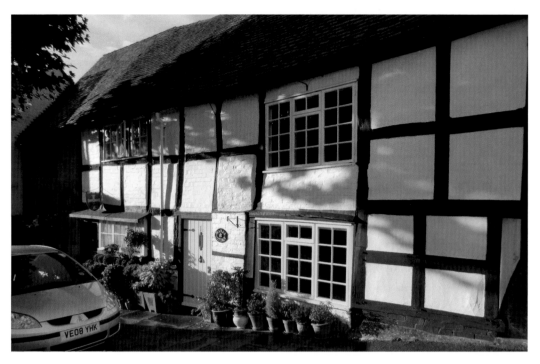

King John Cottages

The low afternoon sun in early autumn illuminates these lovely cottages near King John Bridge on the A438. This row of ancient dwellings is very low lying and suffered badly in the 2007 floods. Although I did photograph them at the time I have avoided including those pictures out of compassion for the owners during what must have been a traumatic time.

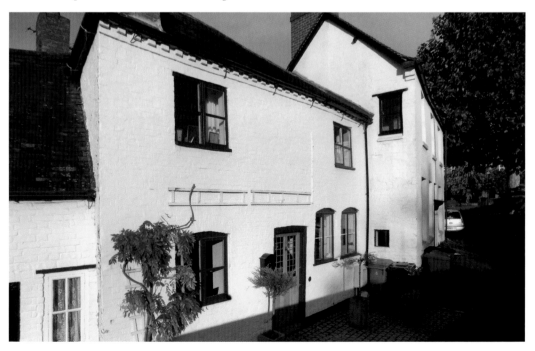

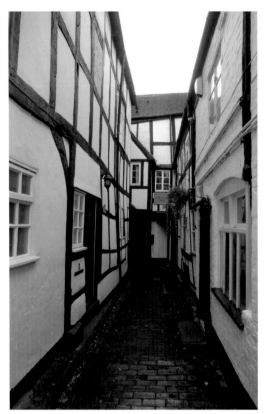

Wallis Court and the Tudor House Hotel
This alley is one of Tewkesbury's finest, a popular cut through between Oldbury Road and the High Street, emerging next to the Nottingham Public House. The Tudor House Hotel is not quite what it may appear. It was a school of one type or another until the Victorian era, and its frontage is mock Tudor built around the same time. It is actually a much older building, originally with a brick façade.

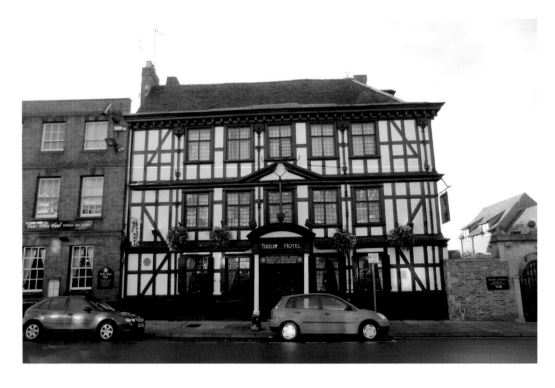

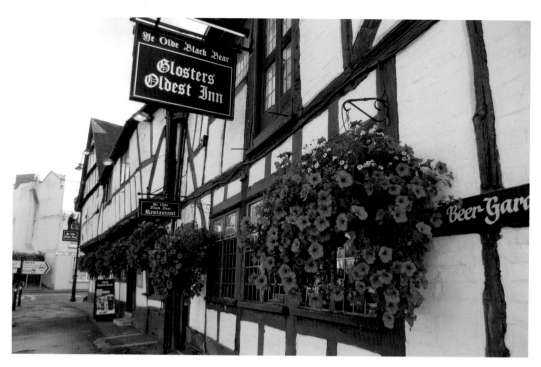

The Black Bear Pub

Gloucestershire's oldest inn, dating back to 1308, the Black Bear is as full of character inside as it is out, with plenty of quiet nooks and crannies away from the big screen sporting events. Its garden runs down to the banks of Mill Avon, and are prone to regular flooding.

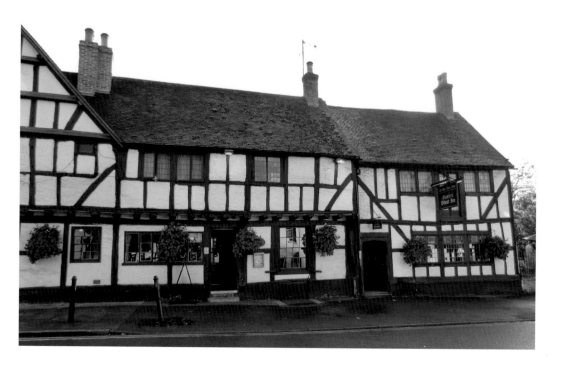

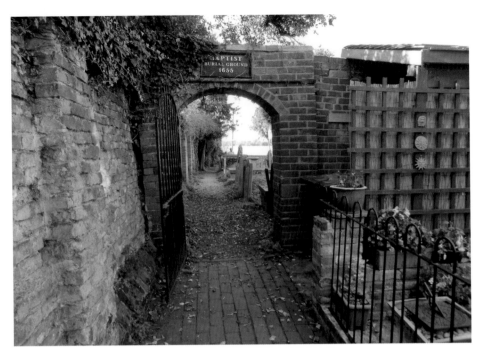

Baptist Burial Ground

One of Tewkesbury's relatively little-known quiet spots is the Baptist burial ground. It can be found at the end of the long Old Baptist Chapel Court in Church Street which also houses the chapel itself and offers lovely views over the Avon. The graves are very old, although sadly most are almost impossible to read without tracing paper and crayon. It is little visited and a peaceful spot.

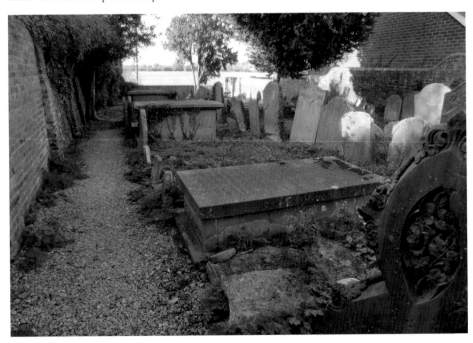

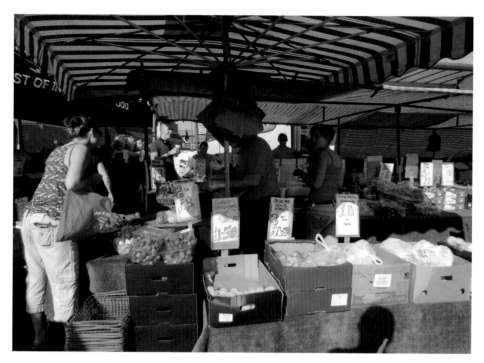

Tewkesbury Market

Tewkesbury has had two market days for hundreds of years on a Wednesdays and Saturdays, and its heart was originally on the site of The Cross, at the junction of Tewkesbury's Y-shaped street structure. These days it can be found in Oldbury Road car park. While its gradual decline cannot be denied, many a bargain, and more importantly fresh seasonal fruit, vegetables and meat, is still sold here.

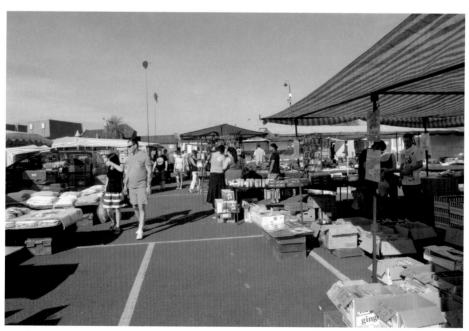

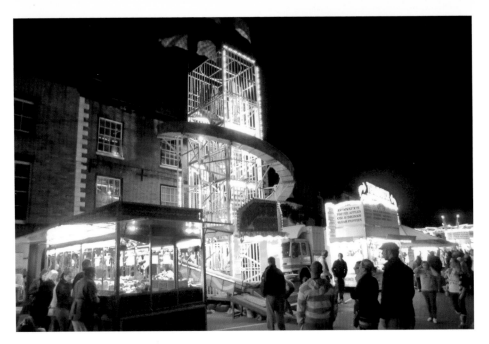

The Mop Fair

Tewkesbury Mop Fair is the largest street fair in Gloucestershire and one of the largest in the UK. It takes place every 9th and 10th October unless one of those days is a Sunday, in which case it moves back or forward a day. It started as the October Fair when landowners would chose their labour for the coming year. Each labourer would wear their Sunday best, and those without specific specialist skills would carry a mop head. Once terms had been agreed, the mop would be removed, and the labourer would wear ribbons as a sign that they had been hired.

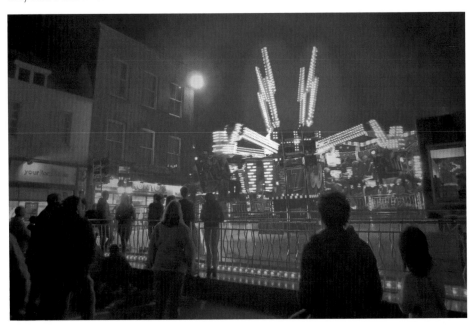

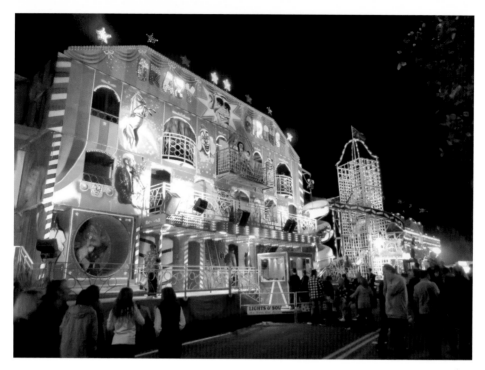

The Mop Fair

Nowadays, the Mop Fair has become a huge funfair, dominating East Street, Nelson Street, Barton Street and Oldbury Road car park. It is promoted by Tewkesbury Fair Society, and brings in visitors from all over the region. As you can see, it is brash, colourful and not to everyone's taste, but to many it is one of the town's highlights of the year.

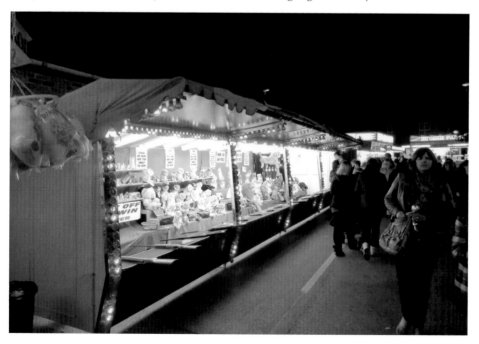

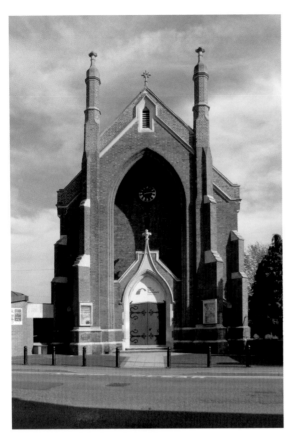

Two More Tewkesbury Churches
Second only to the Abbey in terms of impact, the Holy Trinity Church at the bottom of Trinity Street on Oldbury Road, it was built in 1837. Originally an evangelical church, it is now Church of England. The Methodist Church in Church Street is seen below.

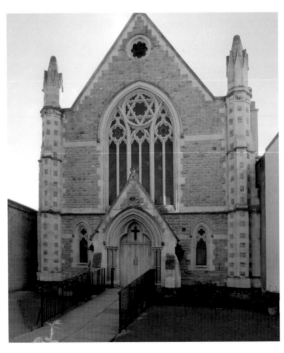

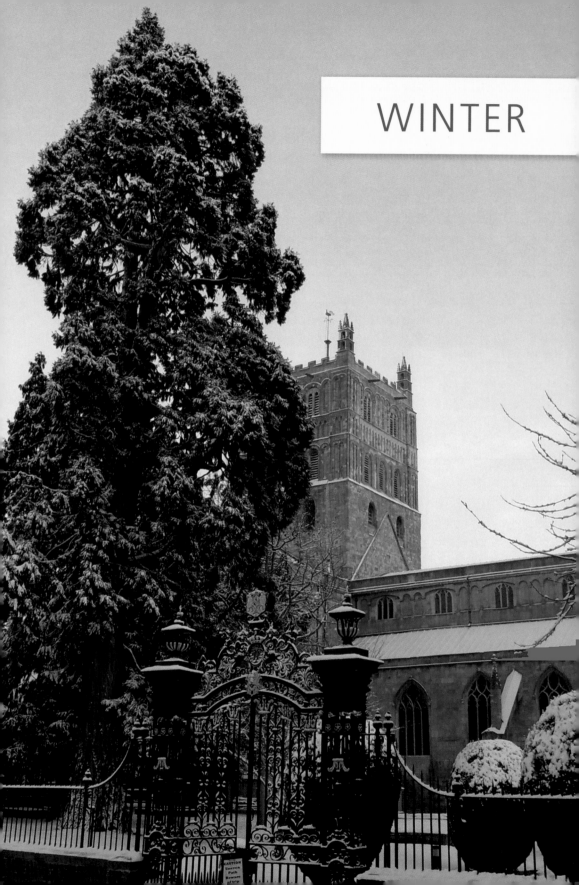

WINTER

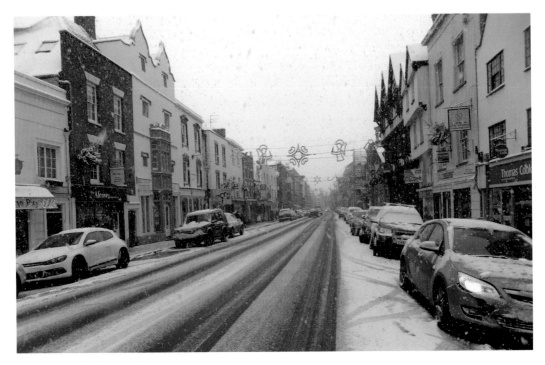

Snow in Tewkesbury High Street

I rushed outdoors to take this pair of photographs of Tewkesbury during a very heavy snowstorm in December. It had only been snowing an hour or so, but the accumulation of snow is already pretty significant. The top picture is a view of the High Street looking down towards The Cross. The lower picture looks directly up Trinity Street towards Holy Trinity Church.

Snow Scenes

Accessed either via the High Street next to the Nottingham pub or via Wall's Court, a rather unpromising modern entrance in Oldbury Road, the Old Bakehouse, now a residential property, takes on a picture postcard appearance in the snow. Also shown is a pyracantha bush, photographed in an alley between Nelson Street and Chance Street. In autumn and winter the town is awash with them.

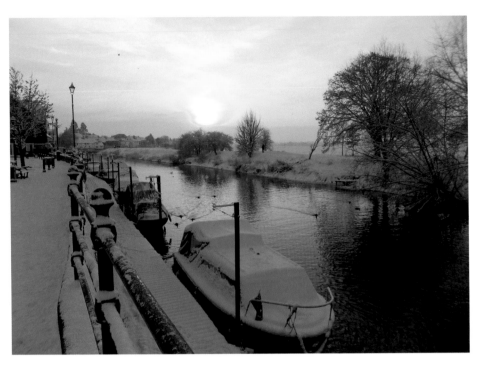

Mill Avon in the Snow at Sunset

Two photographs taken within a few seconds of each other from the same location. Looking Towards Lower Lode and the Abbey (above) the sun is low in the sky and dusk has begun, whereas looking towards Healings Mill (below) daytime still feels with us.

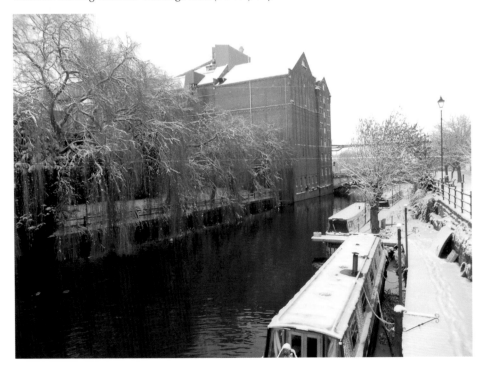

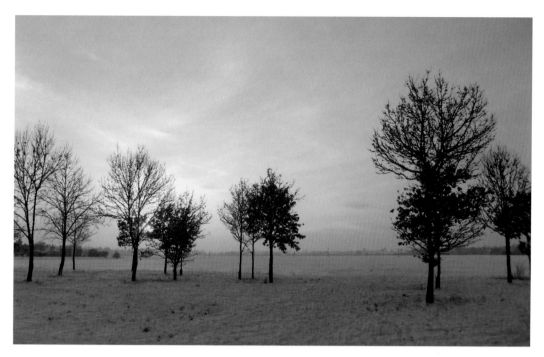

The Severn Ham in Snow

The Severn Ham is the main flood plain between the Severn and the Avon. When dry it is a pleasant but rather unremarkable place to walk. However, in the snow the Ham takes on a different character entirely, as these next few pages show. Above, the sun sets through some of the somewhat sparse trees on the Ham. Below, the Town Council's guide station explaining a little of the history of the Ham.

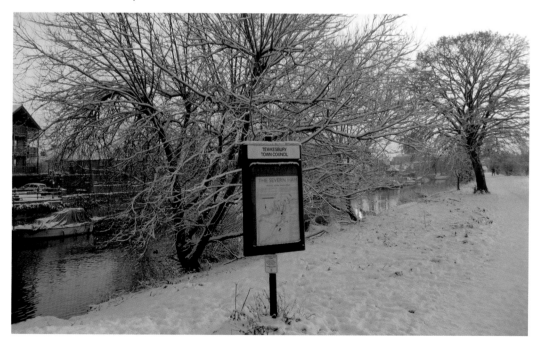

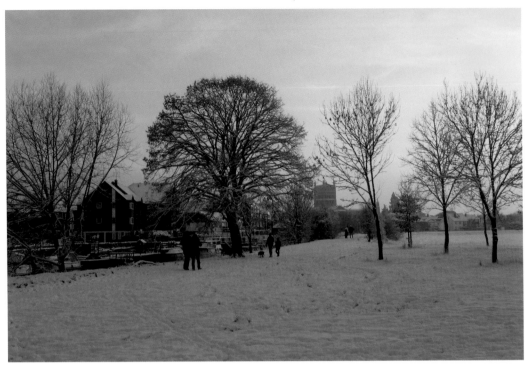

Mill Avon at Sunset
Two more photographs moving along the northern bank of Mill Avon towards Abbey Mill and
Lower Lode.

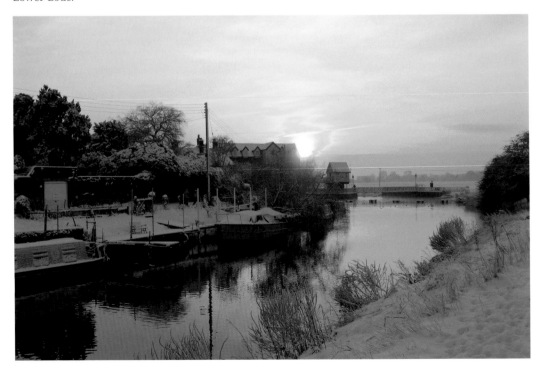

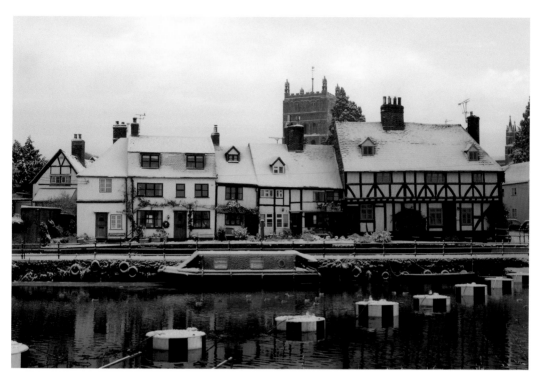

Abbey Bank Cottages
Once again, these cottages are particularly spectacular in this winter scene, photographed from the opposite bank of Mill Avon.

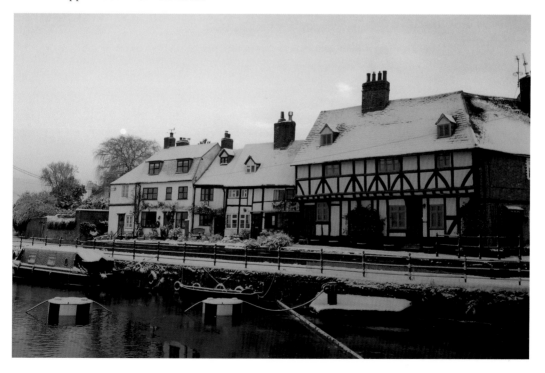

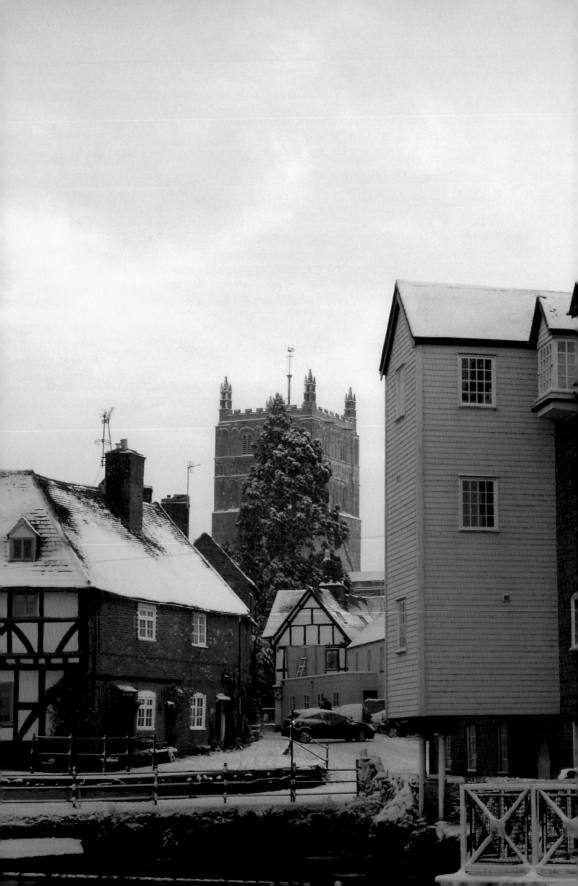

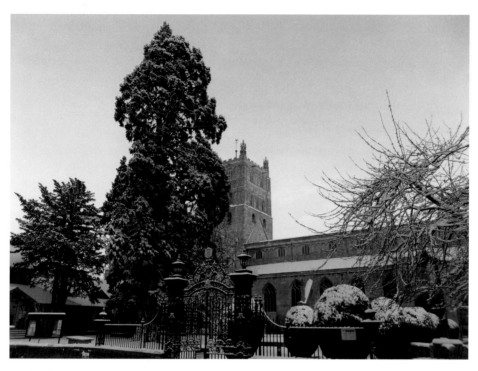

Tewkesbury Abbey in Winter
The evergreen trees in the Abbey grounds look spectacular here, and details, particularly the impressive ironwork of the fence and gate, seem to take on new significance against a backdrop of white snow.

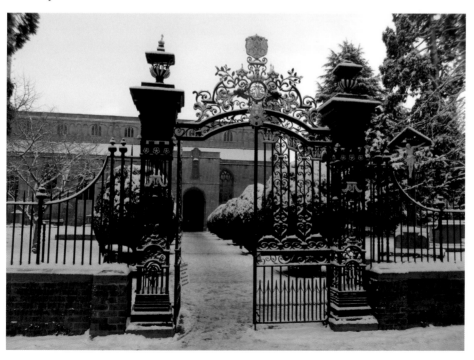

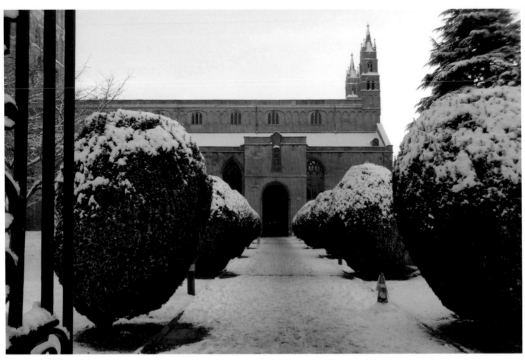

Tewkesbury Abbey in Winter
The sculptured bushes in the Abbey grounds look like they have been specifically created to be photographed in the snow.

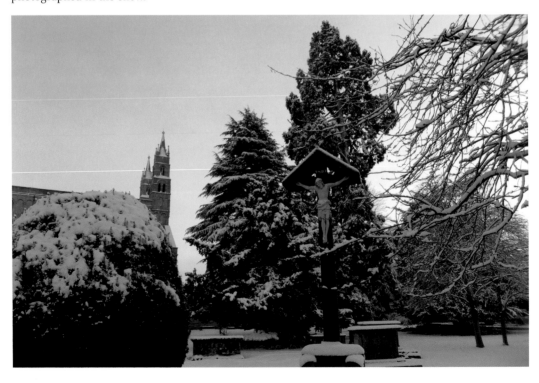

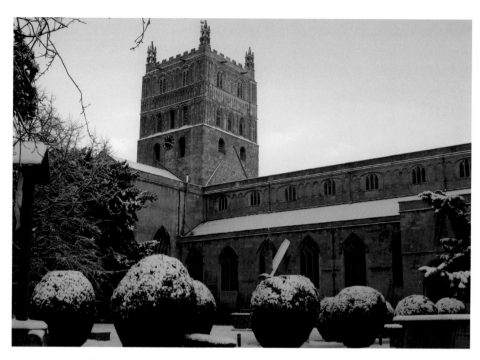

Tewkesbury Abbey Grounds in Winter

The sculpture in the bottom picture is called *Touching Souls* and is by the sculptor Mico Kaufman. It's an exact replica of the same sculpture in Tewkesbury, Massachusetts. Cast in bronze, it shows four children, native-American, European-American, African-America and Asian-American, sitting on the ground, leaning back on their hands, with their legs outstretched and the soles of their feet touching. For some reason I didn't really notice it until I saw it in snow.

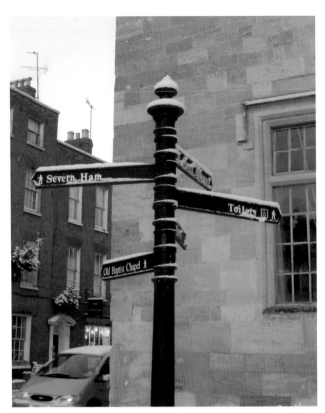

Signpost and the Bell Hotel

A typical Tewkesbury town signpost, flecked with snow, and the white frontage of the Bell Hotel, almost camouflaged in the winter conditions. The site originally housed one of the Abbey buildings, and after the Dissolution became a tannery, before being rebuilt as an inn in the sixteenth century. It now has twenty-four guest rooms and a comfortable bar area.

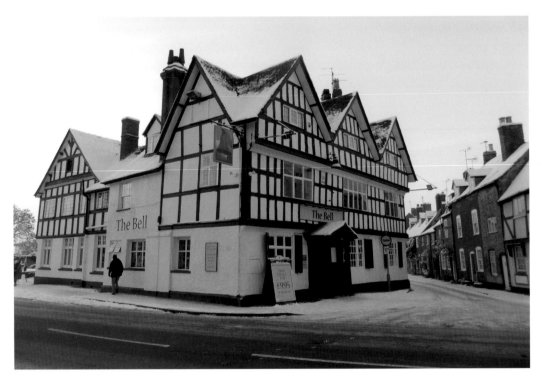

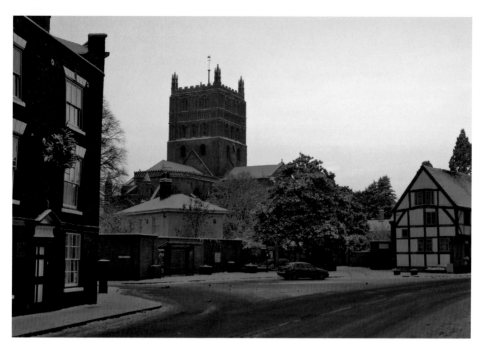

Church Street at Dusk

Looking back from Church Street, the Abbey cuts an imposing figure at any time of day, but at dusk and in snow it looks particularly impressive. The town's Christmas lights are subtle yet effective. Here we see a set suspended from one of the town's oldest pubs, the fifteenth-century Berkeley Arms in Church Street.

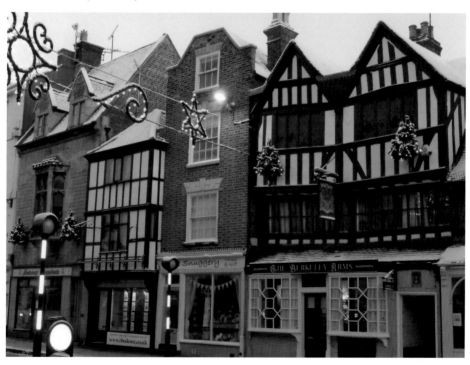

The Cross and War Memorial

A close up of the war memorial in heavy snow, still showing the Remembrance wreaths from 11 November. Amongst the wreaths on display are those from the Fair Society and the Chamber of Commerce. In the gathering dusk below, we see the war memorial with Church Street behind it.

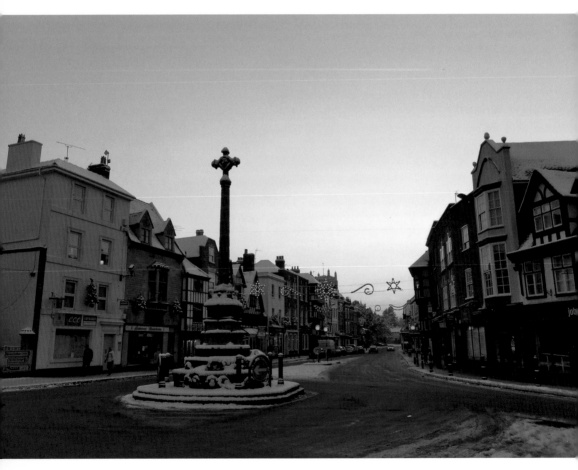

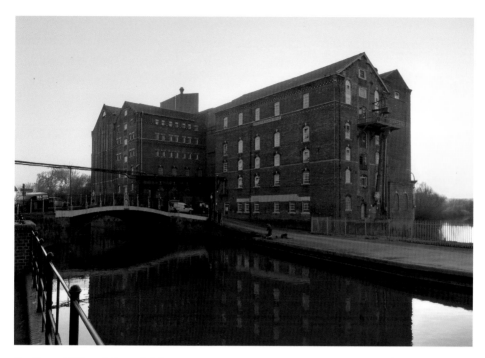

Healings Mill and Quay Bridge

Healings Mill in all its eerie glory in winter. A lone fisherman stands by the slip road. Having been refurbished by Allied Mills in the 1970s the mill ceased production in October 2006, and forty jobs were lost. Here also is a close-up view of the sign on the wonderful cast-iron Quay Bridge.

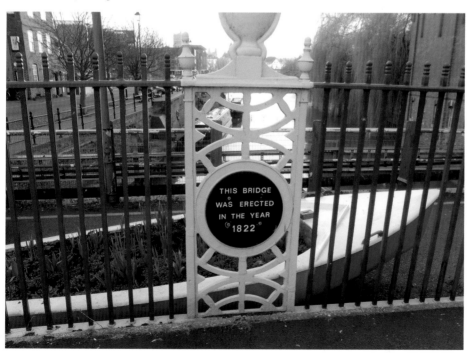

THIS BRIDGE
WAS ERECTED
IN THE YEAR
1822

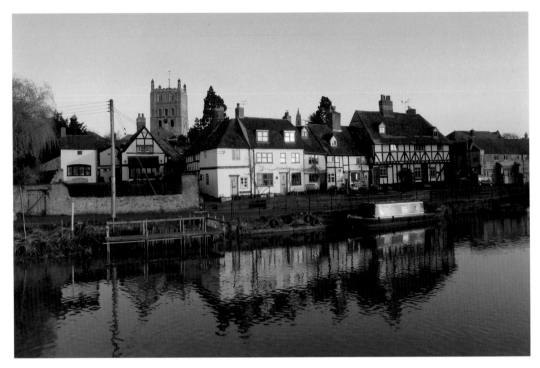

Abbey Mill and Cottages

The low winter sun here shows off the delightful cottages next to Abbey Mill, photographed late in the afternoon from the north bank of Mill Avon. A few yards further along, and the mill itself and the more recent flood defences come into view.

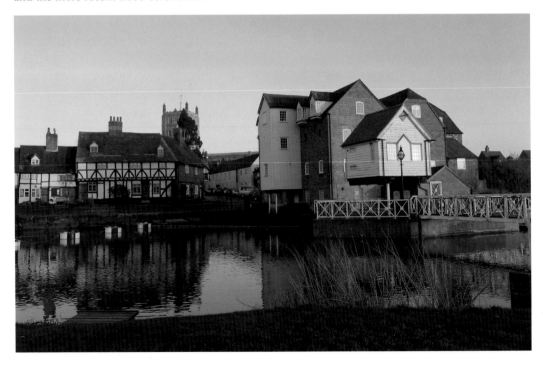

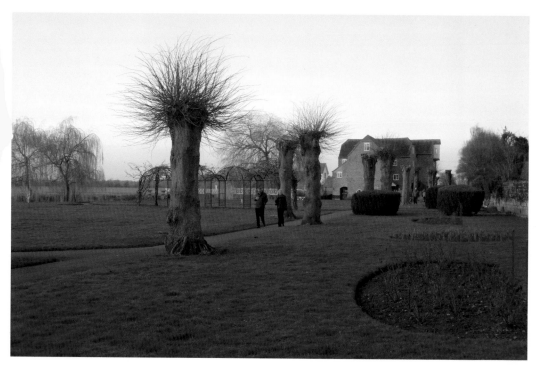

Victoria Pleasure Gardens

Trees bare, flowerbeds empty, Victoria Pleasure Gardens in March have a bleak beauty in stark contrast to the flower filled scene in Summer. On the following page, a final look at Abbey Mill cottages in snow to end our journey through the year.

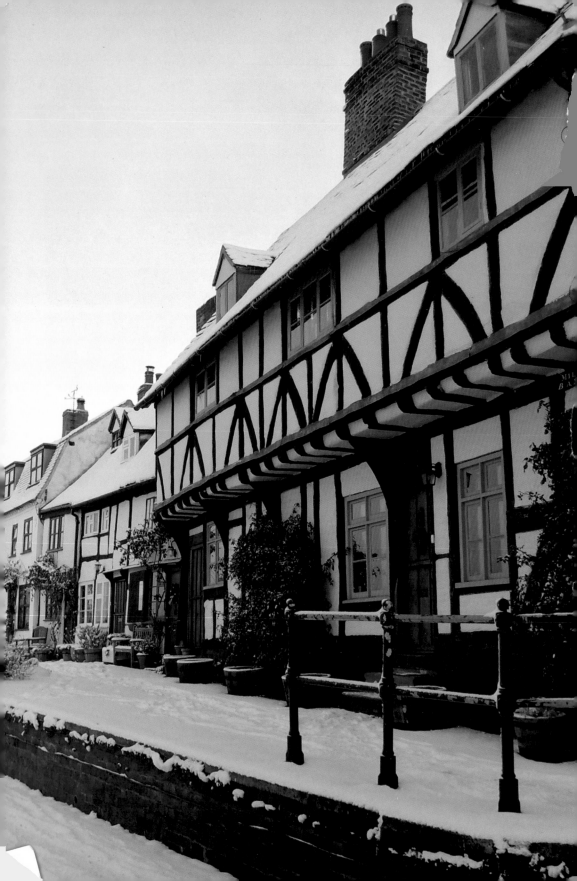